A Story of
North Carolina's
Historic

Beaufort

A STORY OF
NORTH CAROLINA'S
HISTORIC

Beaufort

MAMRÉ MARSH WILSON

Charleston London

History
PRESS

Published by The History Press
Charleston, SC 29403
www.historypress.net

Cover image: *Old Port Town. Courtesy of Alan Cheek.* www.alancheek.com.

First published 2007

Manufactured in the United Kingdom

ISBN 978.1.59629.168.3

Library of Congress CIP data applied for.

CONTENTS

ACKNOWLEDGEMENTS

To those who came before, perhaps not knowing where they were going and in some instances why, but landed here in Beaufort, built homes and businesses, worked hard for the community over the years and left the legacy of name or family…thank you.

To those who have come in recent years, have restored and preserved many of the old houses built by those before them, have cared about the past and the future of our town, have made Beaufort home and raised children and grandchildren here…thank you.

To those who will come in the future, remember the history of this quaint, little, peaceful village called Beaufort, learn from others who have come and gone, take care of each other and enjoy a stroll through history every now and then…thank you.

To the many folks who have helped me with research writing this book, as well as others encouraging me, guiding me and praying for me…thank you.

To my family, friends and coworkers who have kept me going these past few months by ignoring my moodiness, my not answering the phone, writing notes or being there for them…thank you.

To the wonderful, cheerful, helpful folks at Eckerd Pharmacy and the photo lab personnel for their patience, understanding and knowledge of photography as well as making the prints come out right…thank you.

To a flying photographer and friend, Stoney Truett, and his pilot with Seagrave Aviation, Frank Hauman, for the wonderful, expansive, aerial photos of the town, perhaps showing Beaufort as few have ever seen her before…thank you.

To Tony Smith for the time spent talking about the family, the loan of newspaper articles about the tenth anniversary of the *Challenger* disaster and especially the loan of photos of Mike and the crew…thank you.

To John Betts, manager of the Beaufort/Morehead City airport, known today as the Michael J. Smith Airport, for trusting me to return the scrapbook about the airport, the CAP information that he had and for the time spent talking with me about the airport and Mike Smith…thank you.

Lastly, to my Father in Heaven who has supported me throughout my life in all that I have done and will do, but especially at times when I think I cannot go on. He is my rock and my shield. I thank you.

INTRODUCTION

In writing this book about Beaufort, my hometown now for over thirty years, I wanted to provide the reader with a taste of what the town has been like for more than three hundred years, though it is now changing. In the spring of 2006, a plaqued historic home next to mine was destroyed to accommodate new development. There are changes like this occurring up and down the Inner Banks of our state, particularly along the Albemarle and Pamlico Sounds as well as here in the third-oldest town of the state. The destruction of my neighbor's home was very moving for me. What follows are my thoughts from that day.

Sunday, April 16, 2006
This is the day the Lord has risen. In a few hours I will be attending services at St. Paul's Episcopal Church. I should be grateful and pleased to be able to do so. However, there is an anxiety and fear within me this day that has been building over the past weeks.

It is what is happening in this town, this county, this state, this country and around the world. People today apparently have no regard for others around them, especially when it comes to appreciating their heritage and the history of the community.

When I first came to this charming, idyllic, small town over thirty years ago, it brought back memories of where I was born in Milford, Connecticut, along the Long Island Sound. As a child, I spent some of the happiest days of my life there playing in the clean waters and on the sandy beaches, walking along the narrow streets to and from my grandparents' home.

In the early 1970s Beaufort was a small dot on the map, as far away from the noise and busyness of the larger cities as one could get. It was the peace and quiet, the folks who cared about each other, who had grown up surrounded by extended family, the water, the fishing boats, the tree-lined streets and the history of this community that made life here so pleasant. What fun to watch the menhaden boats move along Taylor's Creek and to wake the next day with the smell of "money" surrounding the village.

Beaufort was a destination, not just a "happen to be going by" place.

Change is a constant, like the tides that roll in and out of our channel and along our waterfront. Much of what is happening in our town has been slow in coming. Yet today we find that most people coming to town are interested in owning a home that has little

need for restoration, with no yard to keep mowed or flower beds to be weeded. In some cases, bigger is better. Some of the earlier apartments, built in the middle of last century and rented by the month, have now become town houses or condominiums, purchased in a lump sum. There are very few places one can rent, the way graduate students from Duke University working at the marine laboratory, or summer visitors from inland, did in the past.

We have been blessed, however, with the forethought of some citizens who cared about the historic nature of this community and established, in 1974, the Beaufort Historic District that is within the National Historic District. The local district covers nearly the same blocks that were laid out in 1713. In this area, our Historic Preservation Commission governs all changes, additions or deletions to homes built more than one hundred years ago. The commission also receives and approves the plaquing of some of these properties. Unfortunately, the local district does not include many of the other historic structures on the fringes. Some of these homes have been purchased of late, destroyed and replaced by modern houses, with no care or thought as to their history or the families who occupied the properties over the past centuries.

Houses here in town have been moved around like matchboxes, from one location to another, over the years. Older houses may have been damaged by storms or other natural causes, as well as neglect. At one time the owners of the beautiful, large homes built in the late 1700s along our waterfront were occupied by the descendants of the builders. Many have been lovingly restored and preserved. Some have been made even larger by the new owner who purchased the property when the former could no longer afford to pay the taxes.

Some of the smaller cottages built in the eighteenth century still stand today, nearly the same as then. They are somewhat hidden from the ravages of the weather and have survived all these years. It is these large Front Street homes—as well as some "smaller" ones on Ann Street and many of the cottages—along with the builders and their history, that are the subject of this book.

From its beginning, Beaufort has seen growth, albeit sometimes in small steps. Many of the people who came here and settled the town built the industries that created more growth. Shipbuilders from New England in the 1730s started our large and booming boat-building companies of today. The sea and its mysteries helped establish national and university-wide laboratories for marine study. As time went on, the need for churches, courts and jails, schools, libraries and other businesses was realized. The population grew slowly in the beginning, with a spurt following the Revolution in the early 1800s, and then steadied again until well into the twentieth century. The industries of Beaufort, primarily that of commercial fishing, have dwindled over the years. Fifty years ago or so, the thought of inviting people to visit this historic town was developed and today tourism is promoted and is now the means of living for many in Beaufort and Carteret County.

History and Flavor

How It All Began

The history of this small community in what is known today as Carteret County in the state of North Carolina is long and involved. In the book *Beaufort, North Carolina* written by this author and published in 2002, there is a full chapter on the discovery of our coast in 1584. As many folks know, Sir Walter Raleigh sent four voyages over several years to the New World. It is supposed that the first settlement in North Carolina was at Manteo in the upper northeastern part of our state.

At a later time, after the Virginia settlement at Jamestown, many curious and daring men in that area explored south into the northeastern part of this state along the rivers and sounds. Some settled in the area that soon became the center of the new province of Carolina. As early as the late 1600s, several of those settlers did further exploration along the sounds of Albemarle, Pamlico and Core. Seeing goodly land protected by large sand banks and with deep water near the mainland, they began buying and settling in the area.

The Lords Proprietors, a group of Englishmen who were in the circle of family and friends of King Charles II in 1676 with names familiar in the states of North and South Carolina—Hyde, Clarendon, Albemarle, Craven, Berkeley, Cooper and Carteret—had extended settlements to the south. By 1696, with interest high in what was happening, the county of Bath was established. Within ten years, the growth was such that the governor's council, the governor and twelve gentlemen he chose divided the county into three precincts, with two representatives each to the general assembly. Towns that sprang up early on in these new precincts included Edenton in Chowan Precinct, Bath in Bath County, Beaufort in Carteret Precinct and New Bern in Craven Precinct.

A Town Is Born

Beaufort was born in the early 1700s primarily because the powers that be, the Lords Proprietors of England, saw the possibility for a deepwater, safe-haven port. Owners of land in the northeastern part of the colony, in their ever-increasing desire to learn more

about their surroundings, came south, exploring the rivers and sounds along the way. At some point these searchers discovered the waters along Core Sound, which lay hidden from the ocean by the sand banks protecting the area. Although the Coree were living here, these Englishmen took it upon themselves to take up the land primarily along the sound by traveling inland a bit through the streams and waterways. Many of the rivers and creeks today bear the names of these explorers.

Based upon research by this author and a paper in 1963 by Charles L. Paul, settlers from the northeastern part of our state began to migrate to the Neuse River, which is a part of the northern boundary of Carteret County. By 1706 some of these folks had even come across the river and made homes there. Exploration and migration continued south until about 1709, by which time people were building homes and businesses around the North River and Newport River.

By 1709 a number of the folks from the northeastern part of the "state" and even the "country" of New England had moved into this area. Farming was begun and fishing and whaling were good. Small houses were built to sustain the men and their families, and these folks were supplying food and other commodities to their neighbors to the north along the Neuse River. The Coree and others, however, were not too happy about the invasion of these foreigners and the Tuscarora uprising of 1711 occurred, lasting two years. The uprising was quelled by Indians and militiamen from the South.

Earlier settlers or purchasers of property in this area included Farnifold Green in 1707, John Nelson in 1708, along with Francis and John Shackelford, for whom our Outer Banks is named. Others included John Fulford, Robert Turner and Enoch Ward, who lived and worked here, intent on making a community grow. There were others, such as Christopher Gale, Thomas Cary and Richard Graves, who merely speculated on land along the waters in the precinct.

A further indication of settlement in Beaufort was the order of the general assembly to have a fort built on Core Sound to protect the people from "some few Coree Indians" lurking about. It appears that Green and Peter Worden of Pamlico River had thoughts about the prospect of a port in the area. Topsail Inlet, today's Beaufort Inlet, sometimes referred to as Old Topsail Inlet, allowed ships to come into the deepwater harbor from the ocean only two miles to the south. They renamed the Core River flowing into Core Sound on the west side of the town as the Newport River.

STREETS OF BEAUFORT

It was following the Tuscarora War of 1711–13 that the first attempt at mapping the area occurred. Green sold the property he had purchased earlier to Robert Turner of Bath town, who obtained permission from the Lords Proprietors to lay out a map of the town he called Beaufort. In 1713, Richard Graves, an early speculator as well as the deputy surveyor of the province, drew the plot map that was recorded in the office of the secretary of the colony. This map, with some additional lots in Old Town and the creation of New Town, still exists today.

Hungry Town, or Fishtown, drawn by the deputy surveyor of the province, included only 106 lots, beginning with number 1 at the eastern end of the town on Pollock Street. Only two streets, Ann and Broad, are shown running east and west parallel to the waterfront at the south, and only six north-south streets are named. These are, from east to west, Pollock, Queen, Craven, Turner, Orange and Moore. Deeds as early as October 17, 1713, name these same streets and the lots.

Streets were named in honor of many of the English ruling party: Ann and Queen for Queen Anne and Orange for William III of Orange, who had served before Anne on the throne of England. Turner, of course, was to honor Robert Turner, who had the foresight to see the potential of the town. Pollock was named for the acting governor of the colony, Thomas Pollock, who served until 1714. Craven was for a Lords Proprietor, as was the name of the town itself, for Henry, Duke of Beaufort.

ADVERTISING AND PROMOTION

As soon as the map was drawn, Turner began promoting sales of lots and what a boon this port would be to all who lived here. He sold lots to a number of his "friends" who lived in Bath, such as Christopher Gale, who purchased 16, 17 and 18 on the harbor as well as 52 and 62 behind. Mr. Bellinger bought lots 29 and 34 while a Captain Sullivan purchased 28. James Davis (not the 1800s house builder) purchased 6, 48 and 58. Colonel James Moore of South Carolina bought 31, 32, 33 and 34, while Major Maurice Moore, a hero during the Indian uprising, became owner of 25, 55 and 65. Captain Hale, also of South Carolina, took 30, 56 and 66. Thomas Roper, 4; Thomas Hardine, 46; John Slocum, 21; John Porter, 9 and 10; William Hancock, 33; William Brice, 22; and Captain John Royal of Boston 1, 2, 47 and 57. Apparently all lots lapsed, except those of Gale and Maurice Moore, since they were purchased on speculation.

By 1720, Turner was back in the Pamlico area representing Beaufort County, and particularly Bath Town, in the colonial assembly. He sold the property he had purchased from Green to Richard Rustull for £150. Rustull was one of the first justices in the precinct, as well as being a vestryman for St. John's Parish, a tax collector, town commissioner, treasurer and customs collector for Port Beaufort. His home, built at Town Creek on the north side of Beaufort and near the "road to Newbern," was also used as the first customhouse. This small, story-and-a-jump, gambrel-roof house has been lived in and carefully preserved over the centuries by many local preservationists, including Dr. John Costlow and his wife, Virginia, who have turned the house into a museum of early construction in the past several years. Today the Beaufort Women's Club is proposing to buy the property and have it relocated to the upcoming Olde Beaufort Seaport at Gallant's Point.

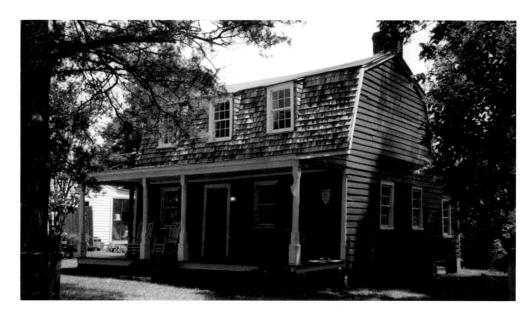

The Ward-Hancock/Richard Rustull house and early customhouse museum. *Courtesy of the author.*

INCORPORATION

Ten years after Beaufort was laid out and at least fifteen years after the first permanent settlers arrived, Beaufort was officially incorporated. The major reasons for this were that the town was already laid out, lots were being sold, buildings were being erected and progress was being made in the growth. There was also a petition from the people requesting that the Lords Proprietors establish the town into a seaport.

A quote from the *Colonial Records of North Carolina* by William L. Saunders states that Governor George Burrington made the following comment regarding the incorporation of the town: "This Act is for making a town at Beaufort which tho' a good inlet and convenient, yet the town hath had but little success and scarce any inhabitants."

This act provided for the increase in size to two hundred acres, thus creating and using in many deeds the terms Old and New Town. A 1770 act defined the area and described the dividing line at Pollock Street, where a marker stands today.

GUIDELINES AND STIPULATIONS

When incorporation took place, certain guidelines were established with regard to the operation of Beaufort.

In 1720 Robert Turner had sold his 780 acres of land, which included the town of Beaufort, at that time still only 100 acres, to Richard Rustull, who had settled in Bath County. It was during Rustull's ownership that the incorporation took place. One of the criteria for the act was that the town should be increased to 200 acres. The lots that

had been sold earlier were to be left in the hands of the purchasers, and the land for a church, a town house and marketplace would remain designated as such. The remainder of the land was to be divided into half-acre lots and sold for thirty shillings each, with the provision that the buyer would erect a house no smaller than fifteen feet by twenty feet within two years of purchase. The purchase money was divided between the owner of the town—Rustull, who received twenty shillings—and the town itself to buy guns and fortify the town.

If a lot lapsed for not building, the resale money was to be used for building a church, Anglican of course, and for the use necessary as deemed by the vestry and wardens of same.

It was also stipulated that all lots were to be cleared, streets were to be laid out sixty feet wide, all nuisances were to be gotten rid of and no lot was to be enclosed by "a common stake fense," but paled in with post and rails. Fines were to be laid on anyone caught quarreling or fighting in town, or they would spend twenty-four hours in the jail or sit in the stocks for two hours!

The act also made clear that all business affairs of the precinct would be done in Beaufort. Five commissioners were appointed to handle all of this. In addition, the precinct was to have a church, to be called St. John's Parish. Twelve men were appointed to the vestry, many of whom did not even live in town at the time.

GROWTH AND MORE SALES

During these early years, growth in Beaufort was sparse. At the incorporation of the town in 1723, Rustull increased the area to two hundred acres, but only five lots were sold and these lapsed due to owners not constructing a building on them. In the next year, Rustull sold or deeded the lot where today's Purvis Chapel stands to the vestry of St. John's Parish. A small building was to serve as a church and the courthouse of the precinct until it was destroyed a couple of years later. In 1725, Rustull sold the town to Nathaniel Taylor for the sum of £500—not a bad profit! Taylor extended the township one hundred yards to include what is known today as the Hammock House, and Taylor's Creek was named after him.

The years that followed saw land speculation increase. Between 1728 and 1732 at least twenty-one new lots were deeded and sixteen that had lapsed were resold. Five were transferred from one person to another. In 1728 the new section of town was established, running from Pollock Street east to Gordon Street. This part of Beaufort also used the same numbering system as the original; thus deeds from that point on designated lots as Old Town and New Town. Sales were still meager and in 1731 Governor Burrington described the town as "but little success and scarce any inhabitants." Six years later, John Brickell wrote nearly the same description in his *Natural History of North Carolina*.

Sales of the town and its two hundred acres continued, with Taylor selling the property in 1733 to Thomas Martin of South River in Craven County for £500. Martin then sold the property in 1739 to John Pinder, a mariner from Philadelphia,

Pennsylvania, for £600. Within three years Pinder, not prospering like he thought he would, sold the property for £500 to James Winwright from Albemarle County and New England. James Winwright was a member of the assembly from Pasquotank, a juror, provost marshal and in Carteret County served as a justice of the peace, surveyor, county treasurer, clerk of court, vestryman and town commissioner. Earlier, in 1731, James Winwright had purchased a lot in Beaufort town, and eleven years later he owned all the lots except those previously sold in the town of Beaufort. It was through James's will in 1744 that schools were established and teachers hired for this growing community.

Thomas Lovick, brother of John and son of Sir Edward of London, was appointed the collector of customs in 1732 at Port Beaufort. He purchased several lots in the town along Turner Street, between Ann Street and the waterfront. In 1734 he represented the county in the colonial assembly and in 1736 was the head of the county court of common pleas and quarter sessions. By 1742 Thomas was a vestryman of St. John's Parish and served as a colonel in the local militia during the Spanish invasion. Following his and his wife's deaths, in 1765 George Phenney Lovick sold the remaining Beaufort lots to Joseph Bell Jr., a tailor.

Following the invasion by Spanish privateers in 1747, the entire county had a listing of 320 taxables, with the number in the town of Beaufort unknown. Charles Paul included in his history of Beaufort that a visitor from France in 1765, arriving at the Cape, walked down the beach to a whaler's camp and asked for transportation to the town. He commented that Beaufort was a "small village not above 12 houses" and that the inhabitants seemed miserable, lazy and indolent and were living on fish and "oisters," of which there were plenty.

In the mid-1700s, a family of Huguenots named Piver came into the area and purchased property in Beaufort town along Ann Street. Others followed, and in the years between 1765 and the Revolution there seemed to be more profitability as far as lot sales. Many of the lots were in the western part of town on the waterfront, including properties purchased by Duncan, Nelson, Fisher, Pacquinet, Shackelford, Ward, Borden, Sabiston and others. Thirty-seven lots, or pieces thereof, changed hands in the 1765–70 period, with at least nine having buildings. By 1773 there were enough citizens—sixty families—that a petition was sent to the colonial government requesting representation in the general assembly. The request was denied by the Royal Governor Josiah Martin.

OCCUPATIONS

The occupations represented by the citizens of Beaufort during the 1700s included carpenters, tailors, blacksmiths, mariners, merchants, innkeepers, surveyors, joiners, coopers, shipwrights, shoemakers, fishermen, attorneys and schoolmasters. There was even pirating, and perhaps the best-known pirate in this area was Edward Teach, known as Blackbeard.

Blackbeard and his cohorts, including Stede Bonnett, roamed the Atlantic from the Caribbean to the sounds of North Carolina. Using the inlet near Cape Lookout, they

would enter the Core Sound, anchor and spend some time in rest and rejuvenation, as well as supplying for the next foray. It is said that Blackbeard may have been the builder of the Hammock House, as when in the area, he would row over from his ship, tie up to the porch railings and stay a while. In 1718, near the "poor little village at the upper end of the harbor," so called by Teach, he put some of his and Bonnett's ships into the Inlet, tricked Bonnett into going on to Bath town and sank a couple of the ships, leaving the crews to fend for themselves. He then took off in the one remaining ship, with booty and all, and sailed to Bath as well. Blackbeard died at Ocracoke. A ship that was recently found in the Beaufort Inlet is presumed to be the *Queen Anne's Revenge*, Blackbeard's own ship.

RELIGION AND JUSTICE

Many of the commissioners of the town also served on the vestry of St. John's Parish, which was established in Carteret Precinct in 1722. The first vestrymen included several gentlemen who were also serving in the same capacity at other places in the province. Christopher Gale was a vestryman in Bath; Joseph Bell and John Nelson served in Craven Parish at New Bern; John Bell served in St. Peter's Parish of Pasquotank; and Joseph Wicker served in Currituck Parish. In 1728, Joseph Wicker, as a warden of the parish, ordered that William Davis, his son-in-law, should be paid for rebuilding the church/courthouse on lot 101 Old Town. In 1742, the records of St. John's Parish, Carteret County, begin with Thomas Lovick, James Winwright, Arthur Mabson, John Shackelford, Edward and Enoch Ward, David Shepard, George Read, Charles Cogdell, W. Lovick, Daniel Rees, John Frazier, Thomas Austin and Joseph Bell serving as the vestrymen.

The vestry met annually on Easter Monday and sometimes at other necessary occasions. Besides levying taxes and settling accounts of former wardens, they chose new wardens, scheduled lay readers for the various chapels throughout the county and took care of the sick and poor. Services were held every Sunday in the church in Beaufort, as well as the chapels. In 1755 the vestry made arrangements to have the Reverend James Reed of New Bern visit four times a year to preach and give Holy Eucharist to the residents of St. John's Parish. With the Revolution came the end of church services in the Anglican fashion and the vestry became wardens of the poor. They continued this service until 1843, when a poorhouse was designated.

Other religious organizations also came to the area in the early 1700s, including the Quakers, who settled along the northern Newport River area and built their Core Sound Meeting House. Among the best-known leaders in this community were the shipbuilders and farmers of the Borden and Stanton families, who came from New England in the early 1730s. In addition, Presbyterians and Baptists began coming to the province, and by the end of the Revolution the Methodists had become very active in Beaufort town. The old Anglican church/courthouse building was being replaced in 1774, but due to the establishment of the New America, Anglicanism was no longer the church of the

country. Thus, some of the former members of St. John's Parish turned to Methodism and assumed ownership of the new building. In 1820, the deed was issued for the property, and in 1854 the church building became the black church known as Purvis Chapel.

Justice was through the courts, which met quarterly. Among the early justices were names familiar to the churchgoers in the parish, as they were also vestrymen. John Nelson, Richard Rustull, Enoch Ward, Richard Whitehurst, Joseph Bell and Joseph Wicker were commissioned by the governor in 1724. The clerk of the court in 1724–25 was Joseph Wicker. John Galland (or Gallant, as we know his name today) served from 1727 to 1729. Others who held the post included James Winright, who served from 1739 to 1741, when George Read took over. The clerkship remained in the Read family through the turn of the century, with either George or his son, Robert, in that capacity. The court's duties, besides hearing cases, were to issue deeds for properties bought, sold and transferred, record wills and estates and license public houses and ordinaries, as well as take care of orphans by assigning guardians for them.

In 1736, the need for a jail was apparent from the actions of a person from Harker's Island. The court encouraged Daniel Rees to build this jail on lot 7, which at the time was at the foot of Queen Street, near the water. It was a small log building with specific measurements. Areas were set aside over the years where prisoners could walk about. By 1796, both the courthouse/church building and the jail were in bad shape and the need for new structures was apparent. The courthouse was built at the intersection of Ann and Turner Streets with a jail constructed on an adjacent lot. Both of these buildings would be replaced in the mid-1830s, located on what is known as Courthouse Square. The 1796 courthouse currently resides at the historic site of the Beaufort Historic Association, as does the jail of 1829, built by brick masons at night during the construction of Fort Macon. The brick courthouse built during the same time period was destroyed in the early 1900s after the completion of the 1907 courthouse on Courthouse Square.

Growth and Industry in 1800

The town continued to grow into the 1800s—surviving the War of 1812, the building of Fort Macon on Bogue Banks and a new jail and courthouse in the town, the War Between the States, depression and reformation—and made its way into the twentieth century.

In the early 1800s several visitors to the town made comments about Beaufort and its location. The following citation appeared in a letter book from Thomas Henderson, 1810–11, in which Jacob Henry, a North Carolina legislator and resident of Beaufort, in 1810 stated:

> It [Beaufort] *commands a boundless view of the ocean, continually enlivened with vessels sailing in all directions.*
> *On the southern side of the Inlet stands Fort Hampton which is a pleasing object from the town and forms to make the mariner an excellent sea mark. The town contains 585*

souls, 74 dwelling houses, 10 stores, 8 ships of different artisans, and a place of worship originally designed as an Episcopal Church but now indiscriminately used by all sects of Christians.

Some of the swiftest sailors and best built vessels in the United States have been launched here, particularly the ship Minerva, a well known packet between Charleston and New York. There are at present five vessels in the stocks, two of which are ready to be launched.

According to historian Tony Wrenn, who surveyed Beaufort in 1974, Fort Hampton was very unstable, particularly on its unprotected point two miles southwest of Beaufort. It was useless by 1820. This fort had replaced the former Fort Dobbs, which had been erected in 1755 as a temporary fortification following the attack by Spaniards in 1747. Fort Dobbs appears as in ruins on the Sauthier map drawn in 1770.

With regard to the Episcopal church, it is believed that the building used for services was begun in 1774 or shortly thereafter. Following the Revolution, it became the worship house of the Methodists. The location of this building was on lot 101 Old Town, where the first and second courthouses/Anglican churches stood.

Another comment in *Reminiscences* by the Reverend John G. Edwards, a Methodist minister while preaching at Purvis Chapel in the late 1820s or early 1830s, gives an additional peek into the beauty of Beaufort:

I stand again upon the upper floor of the double piazza of Brother Perry's dwelling and look out towards the open sea. Fort Macon stands on the right of the entrance to the harbor, and a point of land on the left, with an intervening inlet of two miles in width, through which—so to speak—the wide sea is seen stretching away as far as the eye can reach.

At longer or shorter intervals the white sails of coasting vessels are seen gliding along like spectres upon the utmost verge of vision, and occasionally the long rail is seen marking the track of a steamship bound from Savannah or Charleston to Baltimore or New York, or from some northern port to Wilmington.

Inside the bar, the skeleton outline of a Naval craft is discernible under the walls of the Fort. Between the deep water and the town, scattered here and there are sloops, schooners, and smaller craft, creeping along under sail, or lying quietly at anchor.

The Perry residence was located in the second block of Front Street, between Moore and Orange Streets. It did have a clear view of the inlet and fort and the ocean. The house was nearly a duplicate of one next door known as the Nelson house. Unfortunately, the Perry house was destroyed in the early 1920s and the present-day house was built on its foundation.

It is also in this inlet between the east end of Bogue Banks and Fort Macon and the west end of Shackelford Banks that remains of the wreck of Blackbeard's ship, *Queen Anne's Revenge*, were discovered several years ago. The story goes that Blackbeard purposely sunk the ship, took off with the booty and went to his home port of Bath, leaving behind his crew.

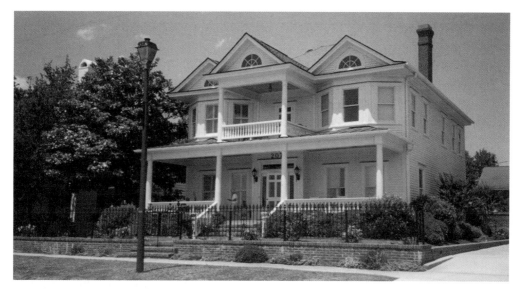

Judge Duncan house, former location of Perry house. *Courtesy of the author.*

FORT MACON AND ITS PRESERVATION

In Paul Branch's book *Fort Macon, A History*, he states that the replacement for Fort Hampton was originally known as the "Fort on Bogue Point." It was designed by Brigadier General Simon Bernard, a former aide-de-camp of Napoleon I and head of the new Board of Fortifications for the United States. He, with his cartographer Captain William T. Poussin, took notes, measured and formed the plan that was used to construct the new five-sided fort to eventually be named for North Carolina's elder statesman, Nathaniel Macon.

Construction began in 1826 and continued to its near completion in 1833. In the spring of 1827 bricks were supplied by local Beaufort men Otway Burns, a privateer of fame from the War of 1812, and Dr. James Manney, a physician who had moved his family to the area. Following the excavation and building of a wharf to receive materials by barge, the cornerstone for the new fort was laid in June 1827. Masons were hired, one of whom had a history in the growth and development of the town of Beaufort—William Jackson Potter of Maryland.

Despite the setbacks due to delayed materials and storms that ravaged the area, the fort itself was actually completed in 1834, although at that time there were no guns, mounts or any other fortifications and outbuildings. In 1840 Captain Robert E. Lee, a young, temporarily unattached engineer, visited the fort to make an inspection of its condition and needs. He reported that there were several problems that needed correcting, such as leaking and erosion of the shoreline at the inlet.

Fort Macon, with all its problems of location at the end of Bogue Banks surrounded by water on three sides and open to the effects of the salt air, hurricanes, tornadoes and wars, has survived and today is one of the most visited state-owned parks. Taken over

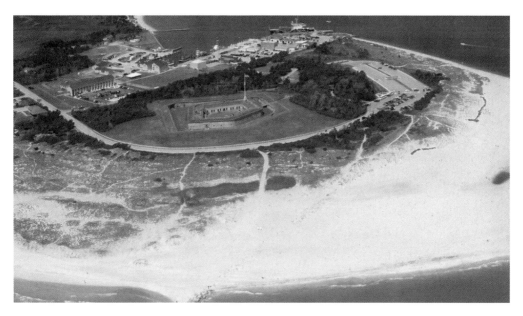

Fort Macon and the Coast Guard Station, an aerial view. *By Stoney Truett.*

by the Yankees in 1861 and used to protect the area during the Spanish-American and World Wars, she basically remains much as she was built in the 1820s and '30s. The primary keepers of the fort, besides those hired by the state, are the Friends of Fort Macon. Over the past several years this group has grown and provided funding for much of the restoration. Fort Macon will celebrate her two hundredth anniversary in the next few years. It should be quite a celebration.

BEAUFORT TWENTY YEARS LATER

In 1853, William D. Valentine came to Beaufort primarily due to his interest in seeing the "future great seaport of North Carolina" that the Atlantic & North Carolina Railroad was heading toward. While in the area, he looked at Gallant's Point near Town Creek, the site of a former saltworks constructed in 1776 at the beginning of the Revolution, and across the river and marshes to the west at Shepard's Point. Many of his comments and descriptions remain today. The citation below is from "The Diary of William D. Valentine, April 26, November 8–10, 1853," located at the Southern Historical Collection of UNC Chapel Hill.

> *There are some very neat residences. Some of the lots are tastefully laid out and ornamented with evergreens and flower shrubs. The evergreens which beautify the town more than others are the live oak and yeopon [yaupon].*
> *There are two beautiful new churches whose tall steeples first catch the eye as you approach the town. They are both on the same square...one belongs to the Methodist*

the other to the Baptist. The first is a large…wooden edifice of fine costly work…the exterior is complete…The most beautiful place in town is the church burying ground of the Methodists [Old Burying Ground] *on which their new fine church is situated as well as their old one* [Purvis Chapel]. *The white tombs and pillars of white stone and marble amid the beautiful evergreens of live oak and yeopon and variety of flowers, render this the most beautiful place of the kind I ever saw, by far the choicest beauty spot of Beaufort.*

The churches indicated are Ann Street United Methodist, built on lot 71 Old Town, and the Baptist church, located on lot 72 Old Town. The Methodist people gave the original worship space, known today as Purvis Chapel, to the black community for their use. The Baptist church mentioned above is believed to have been the courthouse/ Anglican church building that was moved from lot 101 Old Town following the Revolution to a spot adjacent to the burial ground in the middle of the block on Ann Street. The new Anglican church, to become the Methodist church and finally Purvis Chapel, was constructed on lot 101 Old Town. Anglicans, or Episcopalians, had no space of worship until 1855. The moved structure continued to be used as a courthouse until the newer one was built on Courthouse Square when the Baptists began using it for worship. The tall steeple was added to this structure at that time.

The Old Burying Ground actually belongs to the town of Beaufort. The original portion of this burial site was deeded in 1731 by Nathaniel Taylor with the consent of commissioners Richard Rustull and Joseph Bell, Esquire, and included the lots of 71, 81, 91 and 101 Old Town. The earliest recorded burial is dated 1756; however, it is believed by many who have researched and plotted the ground that early settlers of the town and Indians were interred in this sacred space. The Old Burying Ground was the subject of a book, *Beaufort's Old Burying Ground North Carolina*, written in 1999 by Diane Hardy, Marilyn Collins and this author.

PROGRESS CONTINUES: THE MILITARY RULES

Following the War Between the States in the 1860s, Beaufort remained under the command of the military located in Charleston, South Carolina. For several years the Federal government told the town who the mayor and commissioners were to be and what laws the citizens were to obey. According to the Town Record book, 1774–1877, transcribed by this author, Headquarters Second Military District of Charleston, South Carolina, June 14, 1867, issued the following: "Special Orders, No 71, The following named appointments of civil officers are hereby announced: For the city of Beaufort, County of Carteret No. C. Mayor: Thomas C. Allen, Commissioners C.S. Bell, W.A. Moore, William F. Piver, and R.L. Sellick."

In early July, a committee of one was appointed to see to the celebration of the Fourth of July. By the middle of July 1867, thirteen ordinances with amendments were adopted. In October the mayor was authorized to purchase elm trees and have them put in front of the several churches in town before the thirtieth of December.

BEAUFORT REGAINS ITSELF

Apparently the military removed itself from the management of the town of Beaufort after 1868, for in 1870 the commissioners were elected once again by the citizens. Ordinances were again adopted by the new mayor and commissioners, including statutes dealing with hogs running at large to be impounded and sold unless the owner paid the charges for the impounding, as well as horses and mules to be impounded. Charges were to accrue for the keeping of said animals until they were sold. People bathing in the waters of the town between sunrise and dark were to be fined. Barrooms were to close after midnight on Saturday and remain closed until Monday morning and discharge of firearms or even fireworks was prohibited, as were marble shooting, top spinning or hopscotch playing on the streets.

Other ordinances were similar to those drawn during the occupation by the military in 1867–68. In addition, however, there was an ordinance penalizing any persons congregating in front of or in any vestibules of the churches during services. Commissioners of the town ordained as well that any persons found guilty of robbing the nest of or destroying the mockingbird or catbird in the corporate limits would be subject to a penalty. Drunkenness was to be fined or the person imprisoned or both, and disorderly conduct was the same. Dogs were to have collars marked with the town badge denoting the payment of the tax. And if anyone was found throwing rocks, shells or missiles of any kind in the streets, he would be fined. For several years, the ordinance adopted on May 9, 1866, forbidding the letting off or firing of fireworks within the corporate limits was suspended between the days just before Christmas until after the first of January.

AN ACT TO INCORPORATE THE TOWN OF BEAUFORT, AGAIN

By 1877, the General Assembly of North Carolina enacted an act to incorporate the town of Beaufort, which superceded the original act in 1723. The corporate limits of the town were spelled out, beginning on the north side of Taylor's Creek at the mouth of a gut or drain that marked the eastern line of James Mason's land, running north with his line to the northeast corner, then to the southeast corner of the land claimed by the late James H. Taylor purchased from Valentine Manney and others, then north with the eastern line to James Ward's line, then west with his line to the eastern line of Gordon Street to Town Creek, then with various courses of the creek to the thoroughfare, then south to the southern line of water lot 132 New Town and along the north side of Taylor's Creek to the beginning.

The act also stipulated that the officers of the corporation, as it was called, would consist of a mayor and five commissioners, who would have power to lay an annual tax on real and personal property not to exceed 25¢ on each $100 valuation and 75¢ on each poll. They were to elect three commissioners of navigation for the port of Beaufort. The act was to be voted on by qualified voters of the town. The town was to be divided into

five wards: one to be that part of town south of Ann Street and west of Orange Street; second was the part south of Broad Street and between Orange and Pollock Streets; third was the part south of Broad Street and east of Pollock Street; fourth was the part north of Broad Street and west of Queen Street and west of Orange and Queen Streets not included in the first ward; and the fifth was that part north of Broad Street and east of Queen Street. Each ward was to elect a commissioner living in that ward.

The act to incorporate the town of Beaufort, Carteret County, was ratified January 13, 1877.

Early Tourism

By the 1890s, Beaufort was gaining a reputation as a coastal resort and watering place. Thomas H. Carrow, a local citizen, wrote an article in 1948 in the local newspaper, the *Carteret County News-Times*, entitled "Memories of Beaufort in the Nineties." Some of those memories are cited here.

> *The principle hotels or eating houses were the Davis House at the west end of Front Street, run by Miss Sara Ann, and the hotel run by Mr. Bill Dill that had a porch on the second floor from one end to the other. I can't forget Miss Emma Manson's house on Front Street. It was just west of the Davis House. She had a regular clientele and was popular as a hostess. I can recall how, on a summer's evening, both the Manson House and the Davis House porches were filled with happy boarders enjoying the south wind that always seemed a little more delightful in Beaufort.*

The Davis House originally consisted of three houses, with the earliest known as the Warner House of 1774. It was located nearest to Moore Street one house away. Portions of the Davis House can be seen partially on the Sanborn Insurance maps of 1893, 1904, 1908 and fully on the map of 1913. In addition, the chart of circa 1854 shows several houses located in the same spot and Gray's map of Beaufort, circa 1880, indicates the three structures owned by Sarah Davis.

The E.P. Manson House is also shown on the circa 1880 Gray's map of Beaufort and is possibly one of those on the circa 1854 chart. It, too, is on the 1913 Sanborn map.

As far as other "hotels" in Beaufort, on the circa 1880 Gray's map there is the Atlantic Hotel Inn on lots 20 and 21 New Town, between Pollock and Marsh Streets. To the south of this is a basically empty lot with a small house in a part of lot 6 New Town on Marsh Street and a small structure on lot 1 New Town on Pollock Street. A second hotel on the Gray's map is known as the Sea Side House, on Front Street, lots 2 and 3 Old Town, owned by Charles Lowenberg. By 1913, the Sanborn map indicates that the Inlet Inn is built on lots 2 and 3 Old Town with a portion on Pollock Street on lot 1 Old Town. Apparently, the Sea Side House evolved into the Inlet Inn. Today, behind the BB&T bank building and the White House is a vestige of this inn used as apartments.

A third place for visitors to stay is denoted on the circa 1880 Gray's map on Front Street, on lot 20 Old Town between Turner and Orange Streets. Known as the Ocean View Hotel, and owned apparently by a Mrs. King, this same structure and name appears on the 1885 Sanborn Insurance map. Eight years later on the 1893 Sanborn map the name had changed to the Hotel Virginia Dare. None of these hotels or inns exists today.

Mr. Carrow also commented in his "Memories…" on the heavy boat traffic between Beaufort and Morehead City at the time. The train to the coast ended in Morehead City in the 1800s and there were boats running to and from each, in addition to regular boat lines between Beaufort and New Bern and Beaufort and Baltimore. Mr. Carrow also describes Beaufort's chief commodities as "fish and clams."

> *Occasionally vessels of considerable size would anchor in the channel near Fort Macon… I recall very distinctly a three masted vessel lying peacefully in the Fort channel while being unloaded. Her cargo was natural ice from the State of Maine for Beaufort fish dealers. The ice was unloaded from the vessel onto smaller boats and then brought to the county dock in Beaufort [destroyed]. A narrow boardwalk was constructed from the dock to the ice house across the street just east of the Lyman Store corner.*

It is presumed by looking at the 1885 Sanborn Insurance map that the county dock could have been located over the water near the foot of Turner Street. There is an icehouse indicated on the north side of Front Street near the corner of Turner and Front Streets. It is shown to be a two-and-a-half-story building with stairs going up across the front.

EARLY TWENTIETH CENTURY

Tony Wrenn, in his survey of 1974, states that the "last great era of growth which is architecturally important came with the railroad," circa 1906. A new courthouse was built on the lots designated for this purpose: 127, 128, 135, 136, 143, 144, 151 and 152 Old Town. The train depot was built on lot 97 Old Town, where it stands today at the corner of Broad and Pollock Streets.

Mr. Wrenn continued,

> *The overview is not appreciably different from that described in 1810, 1839, 1853, or 1890. From any porch of any number of houses along Front Street one can look almost directly south, across Town Marsh and Bird Island Shoal, to Fort Macon and the open beach [ocean] beyond. The channel into the state port in Morehead City comes directly across Beaufort's waterfront. Fishing boats come and go…there may be 20 or more in Beaufort Harbor, the cut between Front Street and Town Marsh. During the menhaden season these increase greatly in number.*
>
> *At almost any time of the day the marsh ponies can be seen grazing on Town Marsh, occasionally a school of porpoise break the water and play in the cut. As in 1810*

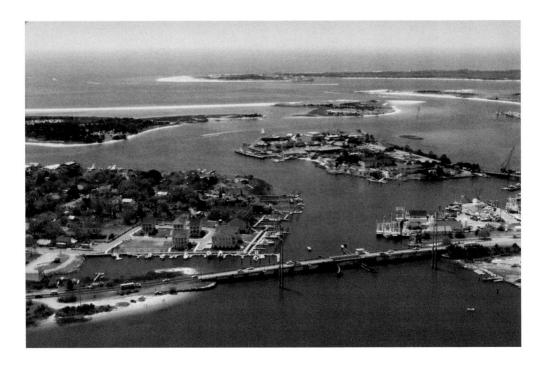

Aerial view looking south to the Atlantic over drawbridge, Gallant's Channel, Piver's Island, Town Marsh and Bogue Banks. *By Stoney Truett.*

Beaufort still "commands a boundless view of the ocean, continually enlivened with vessels sailing in all directions."

In 1900, Dr. Henry Van Peters Wilson, a scientist, researcher and professor of biology at the University of North Carolina, Chapel Hill, was granted $300 to rent a space in Beaufort that could provide laboratory space and a library for use by himself and other researchers interested in marine life. In his essay "Marine Biology at Beaufort" in *American Naturalist* 34, May 1900, his description of the area is essentially the same as that of Jacob Henry in 1810.

Beaufort itself is a quaint and attractive town, with its wide, grassy lanes, and inclining trees [live oaks, mulberries, elms], which show plainly the direction of the prevailing wind. Viewed from the harbor the town presents a long line of white houses that edge the shore, each with its upper and lower porch, from which [more especially from the upper] *the harbor in turn offers a very pleasing picture.*

In the late afternoon, when the glare has become less intense, the picture is one that stays in the memory as a restful composition of sky and water, the latter broken here and there with green marsh islands and white shoals, with sand dunes and breakers in the inlet shutting in the view.

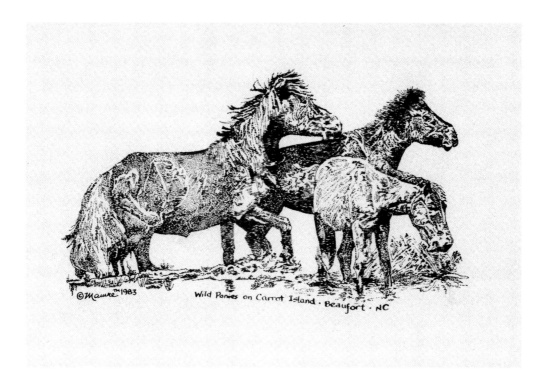

Drawing by author of wild ponies on Carrot Island. *Courtesy of the author.*

An article titled "Sketch of Beaufort Harbor, North Carolina" on letterhead of the Beaufort Harbor Company, written in 1904 by David Whitall Garrigues, included the motto "United We Stand for a Great Harbor." Apparently Mr. Garrigues was trying to sell the concept of a large and useful growing harbor at Beaufort. Some of his writings included the statement that Beaufort Harbor was noted for many naval stores that left her beautiful shores, including "pork from the wild razorback fed and flavored with the succulent nuts that nature bountifully supplied." He also wrote of "turpentine, resin and tar from the pines that made the landscape ever green," as well as "the sturdy live-oak with its knotted and gnarled knuckles, which took centuries to grow and gave a strength to the Yankee ships that only the material can, that has been tempered to the hurricanes of the sea, and which nature has beneficently endowed with a sturdiness equaled only by the sturdy sons of the great 'North State.'"

Mr. Garrigues went on to extol the virtues and advantages of Beaufort Harbor, such as being only forty minutes from the stormy Atlantic to safe anchorage and forty minutes from the safe harbor of Beaufort to the sea, which made the area completely landlocked from the storms and allowed vessels to ride safely within the harbor as well as in the sea harbor outside the inlet while waiting for high tide. Except for the bar at the inlet, vessels drawing twenty-two feet could reach the wharf of Howland Improvement Company. He continued that the inlet should and may be deepened without delay, and today there is a deepwater inland channel and plenty of space for wharfs, quays, basins and roadsteads.

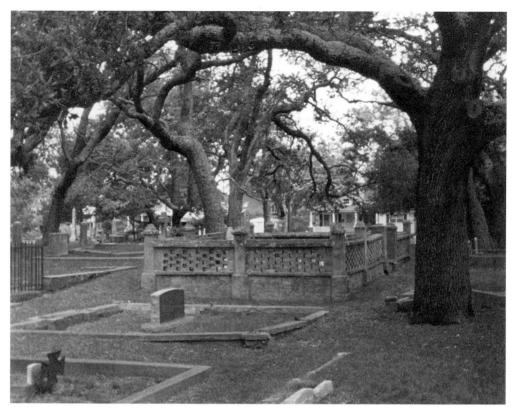

Live oaks of Beaufort in St. Paul's Cemetery. *Courtesy of the author.*

The article contains reports by the assistant to the superintendent of the U.S. Coast Survey in 1851 as well as 1854 and 1857. It is full of wondrous and magnificent reasons why the harbor at Beaufort should be the gemstone of the "twin cities" of Beaufort and Morehead City.

Other comments made about Beaufort and her grandeur and beauty appear in the *Heritage of Carteret County* volumes published in 1981 by the Carteret Historical Association. Among these is that of Francisco de Miranda in the early 1780s. This thirty-three-year-old fugitive from Spain thought he was sailing from Havana, Cuba, to Charleston, South Carolina. The vessel's captain, however, sailed to North Carolina, came in through Ocracoke Inlet and went up the Neuse River to New Bern. From there he traveled overland in two days to visit Beaufort. According to Miranda's diary, he was put up with Mrs. Cheney, whose "gracious company" mitigated the unsociable character of the town.

He wrote that Beaufort was located on a sandy beach, unsheltered, although with sand banks protecting it from the sea and forming the sound. At that time, he wrote, there were about eighty poor inhabitants with miserable houses and no commerce. On a side trip up the Newport River, he commented that the land was sandy and agriculture was difficult. Windmills abounded on the shore and were used to collect water to provide

for two mills, one for wood and one to grind grain. Lumber was one of the primary sources of commerce, according to Miranda.

In 1982, Charles O. Pitts, a local resident and historian, reprinted an article from one of the *Heritage* volumes written by Fred A. Olds in 1925. Mr. Olds stated that although Beaufort town was over two hundred years old, it was still unspoiled by improvements. The waterfront is esplanaded and paved, as are all the streets. Stately trees along Ann Street are whitewashed up to eight feet. Along the waterfront is the seawall facing the inlet with sixteen feet of water, which is three times wider than before the storm of 1878.

The harbor is in front of Beaufort looking south to Bogue Banks, where Fort Macon is located. To the north of the harbor is Core Sound, which runs forty miles east to the Atlantic. The territory between Beaufort and Atlantic is known locally as "down east." On the banks or barrier reefs there are small wild ponies, known as bankers, nearly three thousand in all. Pens are located at various places where ponies are rounded up and checked for sickness or other problems.

The Courthouse Square or park in Beaufort is described as having one section with a "most picturesque" group of live oak trees, a wide stretch of lawn with beautiful plantings and driveways. From the square water can be seen in three directions.

ARCHITECTURE OF BEAUFORT

The houses of Beaufort have been described in various fashions. Some look similar to the New England saltbox style, designs that may have come with the settlers from Rhode Island, including the Bordens and Stantons. Others are described as being from the Bahamian tradition, perhaps from the folks who came to our shores from the Caribbean. The small fishermen's cottages, usually built as a story and jump with a single porch under the extension of the roof front and back, are among the many older houses here. There are also the two-and-a-half-story houses built by the more affluent folks, mariners with ships taking goods to and from Beaufort. Perhaps the most distinguishing feature of these houses is the porch, the ideal place to catch the ocean breeze, particularly along Front Street.

Porches, or piazzas as they may be known, on the larger two-and-a-half-story houses in Beaufort run across the front of the house on both levels with large turned balusters and rails with smaller plain or ornate balusters. Some have porches that are only a small stoop-like porch, sometimes on both levels. Then again, some houses were built with one porch only on the first level. Some houses had porches with no railings, especially on the first floor, which made for some slight danger if one was in the cups, so to speak!

On the smaller houses, porches are generally simple rows of turned or square posts used primarily to support the roof. Some may have the railing and some may not. In some cases these porches provided air conditioning or ventilation for the interior of the house. This could be accomplished in two ways: by leaving off the porch roof or by inserting a sliding trap door in the roof. At the second-level jump, a sash would be placed

The Duncan house at 105 Front Street. *Courtesy of the author.*

that could be opened and closed as necessary. An example of each of these types of early air conditioning can be seen in two of the Piver houses on Ann Street.

Thomas Tileston Waterman, coauthor of the 1941 book *The Early Architecture of North Carolina*, says the following about two-story porches.

> At Beaufort, porches are seen in the form most reminiscent of Nassau, St. Kitts, and Bridgetown in the Bahamas.
>
> The Duncan house on Front Street is a good example of this type of porch. Here a two-tiered porch covers the front of the house and is protected by a shed extension of the main roof. The posts are in the form of crudely turned Doric columns, not unlike those seen in some of the Spanish islands.
>
> In the Davis House, also on Front Street facing Beaufort Inlet, the great length of the house makes a rather similar two-story porch even more effective.
>
> Other examples of early porches in Beaufort range from that on the Mace house on Ann Street, a story and a half building, to others where two-story porches are treated with superimposed columns and covered with pediments. The fact that the North Carolina porch treatment came from the southward and not from Virginia is attested by almost complete lack of porches of the sort above the border.

Tony Wrenn states that much of eighteenth-century Beaufort is incorporated into later houses. Occasionally when entering a house that fits the style of the mid-1800s, one can find remnants of eighteenth-century materials used when the house was first built. Rooflines are another distinguishing characteristic of Beaufort houses. The smaller cottage has a gable roof, beginning with a steeper slope from the ridge and breaking one, two, three or even more times to cover the porch in front and back.

Construction in the very early days was primarily simple framed and log structures. Skilled labor was scarce and materials were hard to come by. As described in the early court minutes of 1736, the first prison in Beaufort was to be twenty feet in length, fifteen feet wide, with walls of sawed logs not less than four inches thick and dovetailed at the corners. Not all buildings in this town were so crudely constructed. As time went on and the capability of purchasing supplies that were delivered by boat grew, houses were built with sawn planks, pegged in some cases, but perhaps nailed with hand-wrought nails made in Williamsburg or Pennsylvania. The lumber, of various thickness, was overlapped to prevent water from seeping in. White pine or cypress was the choice in this area. It was not until the sawmill was in operation in 1851 that lumber became much more available for builders.

In 1986, there was an article in *Spectator Magazine*'s special maritimes supplement about Crystal Coast Architecture. Writers Sharon Lawrence Bradley and Eddie Nickens stated that "architecture has always been a reflection of taste and need." If one owns a home on the coast it can be a "symbol of arrival or a reward for hard work." According to their article, there are three categories of single-family unattached homes here: restorations and renovations, reproductions and contemporary.

When the authors asked builders, architects and restoration experts about this subject, Jim Howland, a restoration specialist for many years, commented in his Carteret County brogue, "Nothing a renovator does should stick out or spoil the effect of the house as a whole. It's like looking at a good-looking woman—it don't matter how good she's dressed or made up. If she's got one eye in the middle of her forehead, it jars you. Same with a house." Jim used to say that the old folks would go off somewhere else, see a style of house they liked, come back and describe it to a carpenter who would build it. The next generation might make some changes, and so on.

One can't date a house simply by walking by because recycling has been going on for a long time, from wood to nails. One person might tear down and toss out boards or timbers they no longer need, and someone else would come along and take them to use in their own house. In order to date a house, you need to crawl under it to see the joists and sills, look at lathing and plaster that may be exposed inside and crawl into the attic under the roofline for shapes and cuts that can say if this is the first roof or how it was finished.

As stated in the Bradley and Nickens article, when the question of how to determine a house's age was asked by a visitor to town, the answer given was "read the plaque." Many of the old houses in Beaufort have been researched to the nth degree and a plaque placed on the front of the house tells passersby who built the structure and the date of construction. There are more than one hundred houses with these plaques, which in the first days were designed and cut out by Dr. John Costlow of Beaufort. Miss Elizabeth Merwin, also of Beaufort, created the "shield" or "coat of arms" for the plaques. A blue-and-silver-checked border was used from the Earl of Carteret's crest signifying "fair play." The red rose at the bottom point represents the Lancaster line of the earl, and the gold fish at the top designates "Fishtown," which was the name of Beaufort in 1713. Over the years, the style of the painting on the plaques has changed somewhat, using

Left: Jimmy Howland, restoration specialist. *Courtesy of the author.*

Opposite: Illustration of original Beaufort plaque by Elizabeth Merwin. *Courtesy of the author.*

blue and gray, with a more artistic rose and fish. Originally, the houses were researched and plaqued by members of the Beaufort Historic Association in the 1960s. Today, the Beaufort Historic Preservation Commission determines the authenticity of the research and awards the plaque.

RESTORATION AND PRESERVATION

Twenty or thirty years ago, people who bought and restored the old houses in Beaufort would talk about the techniques and look for pegs holding beams together, floor joists, mortise and tenon, studs and other visual identifiers of the age of their house. Some folks get so intent on the structure that they want to know who built it, when and how. A trek to the local register of deeds office could take a person back in time easily, and the first connection from one date or person to the next may even cause one to let out a "yeah!"

There is a subtle difference between renovation and restoration. In renovation a person doesn't have to be concerned particularly with the use of historic methods and whether it truly looks like it might have been built hundreds of years ago. Restoration is a careful reading of and listening to an old house. This is a time-consuming way to "redo" an old house, but as one can see in walking through the town of Beaufort and

Beaufort Restoration

BEAUFORT
N.C.
1709

Active Member
196

reading the plaques, a lot of time has been taken to restore many of the eighteenth- and nineteenth-century houses. Restoration and preservation are two terms that go hand in hand. Preservation follows restoration, in that once a person has completed restoration of an old house, preserving it is ongoing.

Many folks today would prefer not to live with the dust, noise, research, reading and listening to an old house that go along with restoration, but those who have taken on the challenge of bringing back to life a wonderful old house are real preservationists. In order for a house, a community, a place that is loved by many to survive and carry on, preservation must be primary. It is difficult to imagine the town of Beaufort falling apart, house by house, siding by siding, chimney by chimney, roof by roof and so on. If the farsighted people who loved this town in the mid-twentieth century had not taken the bull by the horns and begun the restoration and preservation process of the structures built centuries before, there would be no small fishing village for tourists to visit.

BUILDING THE FIRST CENTURY

TRANSPORTATION

During the middle of the eighteenth century, travel was primarily by foot, horseback or boat. Throughout this time, commissioners lined up citizens living in certain areas to take care of the roads, bridges, cuts and water courses, or to actually construct such as needed. All males, white and black, were summoned at times to do the work. Public ferries were established in 1758 as well as an act to regulate inspection of tar, pitch, turpentine, staves, headings and shingles.

In the late 1700s, although the town and county were growing, it was still very difficult to get from here to anywhere inland. Horse, buggy, wagon and boats were about the only way to go. New Bern was accessed by going through Core and Pamlico Sounds to the Neuse River. Towns and villages to the northeast meant travel through the Core Sound, the Pamlico Sound and on into the Albemarle Sound, or by using some of the many rivers and streams flowing into the sounds. The problem with this lack of transportation, according to Governor Dobbs at a board meeting in London, was that Topsail (Beaufort) Inlet led to a safe harbor with deepwater, but no navigable river leading to it.

In 1766, Richard Cogdell, a representative of Carteret County in the assembly, introduced legislation that was approved to build a canal between Harlowe's Creek from the Newport River and Clubfoot Creek from the Neuse River, giving the harbors and ports of Carteret County and Beaufort access to New Bern. Earlier citizens of the area had attempted to connect the two towns through these same creeks by using towpaths and scows pulled by oxen. From the head of one creek to the other they hauled the scow across the lowland.

Following approval of the legislation, the assembly appointed commissioners to lay out the canal and have it constructed by private subscriptions. It was not until 1830, nearly seventy years later, that the canal became a viable entity. But by this time the area was in an economic recession, and it was too late to be of any use to Beaufort.

EARLY INDUSTRIES

Early on, fishing held the number one spot as the primary industry of the town and county. The waters were filled to the gills, so to speak, with all sorts of fish, shellfish and other sea critters. Boat building came along and joined in, thus allowing the locals to go offshore a bit more and bring home even bigger fish. Many of the boats were built to carry the produce from the port of Beaufort to other ports along the North Carolina and Virginia shore.

By the late 1700s forest products were more important to the county than fishing or whaling. These included the production of lumber and wood products, the production of naval stores and shipbuilding. Windmills along the north side of the Newport River were abundant, powering the mills used to cut trees into lumber and grind the grain of local farmers. Many of the homes in Beaufort and other areas were built from the lumber milled in this area.

Before the end of the colonial period there were at least two sawmills operating in the county, one at Gale's Creek in the western part of the county and one at Black Creek. In addition, the Bordens had a mill at Mill Creek. Sawmills were run by water power, produced by damming a creek with tide gates and water wheels. Logs were floated to the mill, where boards, scantlings, heavy timbers and shingles were produced.

Plantations were the mainstay of almost every family who settled in this area, providing food, meat and grain for use by the family and neighbors. Naval stores were also a valuable source of revenue for these plantation owners. A large still would convert the gum of the pine tree into turpentine and resin.

Saltworks and brick making grew in the nineteenth century. In 1765, Robert Williams had set up a saltworks factory on ten acres of land east of Beaufort, where he had purchased two parcels of seventy-five acres, including Taylor's Old Field and the White House (Hammock House) formerly owned by James Winwright. In 1775, the British cut off all supplies of salt to American ports. Thus, in April 1776, Robert Williams and others were appointed by the Provincial Congress at Halifax as commissioners to produce salt. It was at this time that Williams purchased the Gallant's Point property and began the production of salt based upon information he had received from an acquaintance up north. This is the same property where Harvey Smith had his menhaden fish meal plant and where the North Carolina Maritime Museum is currently building the Olde Beaufort Seaport village.

James Manney, a physician and entrepreneur who came from New York in 1810, purchased, in 1814, the property and operated a brickyard there supplying bricks for the building of Fort Macon, the new jail and courthouse and the IOOF building in Beaufort. Dr. Manney sold this business and property in 1830 to Jechonias Pigott, one of his friends and a director of the illustrious canal project.

Other saltworks were built along Taylor's Creek east of Beaufort by Otway Burns and Asa King. By 1826, Burns transferred his part of the plant to Bridges Arendell to cover a debt. Arendell sold the property to Joel Henry Davis I, son of James Davis and brother of James Chadwick Davis. James Chadwick also had a saltworks on his

plantation located on Turner's Creek at Lennoxville, which he left to his daughter, Mary, who married Allen Davis.

THE COURTS, CRIME AND PUNISHMENT

Along with growth comes crime, although most was petty in those days. The justices of the courts would meet quarterly, sometimes in the very early morning and sometimes later in the day. All depended on the weather. Rain and floods messed up the dirt streets, as did snow and ice. Heat and bugs were a bother in the spring and summertime.

The first courthouse was located on lot 101 Old Town. It was used also as the gathering place for worship of the citizens of the community, being that all were Anglicans. Prior to 1728, the building apparently caught fire; perhaps a candle fell over, since there was no fireplace. The final blow was the storm that blew the structure down. In 1728, William Davis, a son-in-law of Joseph Wicker, one of the vestrymen of St. John's Parish, was paid to rebuild the courthouse/church on the same piers or pillars as previously used.

This small wooden building with one entrance and a few windows, which at that time were only holes in the walls for there were no panes or sashes, lasted nearly seventy years with occasional repairs. By 1774, the court appointed William Thomson, Lewis Welch and Robert Read as commissioners to repair the building, but changed their minds a couple of months later and suggested that it be moved to where these men thought was most proper. At about the same time, a gentleman of the parish died and left £100 to build a new church. Well, that made it easy.

The gentlemen commissioners had the building moved to the east end of lot 72 Old Town, adjacent to the burial ground. This most likely meant hauling it, perhaps piece by piece or on a wagon pulled by mules, off the piers it was sitting on, down Craven Street to the corner of Ann Street, making a right turn and going half a block and then placing it on new piers. And there it sat, still being used as the courthouse, even after the construction of the third one in 1796. This is the building that eventually became the first Baptist church. And if you wonder what happened to the old piers on lot 101 Old Town, the new church that was begun there eventually became Purvis Chapel.

As stated, by 1796 the need for a new courthouse was evident. Records needed a place to be kept, the old courthouse building was still in constant disrepair and the town was growing along with the crime rate. In February, commissioners were appointed to find the place and hire someone to build the new structure. The site chosen was the intersection of Turner and Ann Streets, still dirt and muddy at times, but surrounded by trees, and facing south one could see the town harbor. It was also nearer to the area on the west side of Turner Street where town business was taken care of.

As for the jails or prisons of Beaufort and Carteret County, the first was built in 1736 on lot 7 Old Town by Daniel Rees. It was twenty feet long, fifteen feet wide and had sawed logs not less than four inches thick, dovetailed at the corners. The floors above and below were to be laid with plank not less than four inches thick. In the middle was

to be a partition with a door and lock. A strong double door on the outside was to be no less than three inches thick, with good strong hinges and a substantial lock fit for such a door. Two front windows, each two feet high by eighteen inches wide with proper iron grates to the same, were ordered. The pitch between floors was to be no less than seven feet, and the roof was to be covered with good pine shingles well nailed.

By 1755, the courts ordered that a prison bounds be established. The first bounds were to be three acres or 130,680 square feet. Through plotting and calculating, Jim Howland, a restoration specialist, and I came up with what we felt was most likely the plan. The bounds were to cover the first block of Queen Street (25,000 square feet) to Ann Street, down Ann (24,980 square feet) to Craven, up Craven (15,400 square feet) to the south side of Broad Street, then to take in the four lots on the west side of Craven—71, 81, 91 and the courthouse lot (65,340 square feet)—which would equal 130,720 square feet. Prisoners could walk in the streets between the jail and the courthouse or even stroll through the lots set aside for the cemetery.

Ten years later the bounds were changed to begin at the high-water mark on the east side of William Thomson's wharf, run along the shore to a stake to the west of Joseph Bell's house and then north to a cedar bush a little above the courthouse. This would include the courthouse in a straight line to the back of Captain Keys's garden, then parallel the shoreline opposite the first station and south to that beginning point. William Thomson owned lot 6 Old Town at the corner of the waterfront and Queen Street. Joseph Bell's house was on lot 18, at the corner of the waterfront and Turner Street. The possibility was then, after strolling along the waterfront, that the prisoner would go partway up Turner to what Sauthier called the road to New Bern, follow it beyond the courthouse, still on lot 101 Old Town, then go east to just beyond the east side of Queen Street and south to the beginning.

Following the move of the old courthouse building and the construction of the third one in the middle of Ann and Turner Streets, it is proposed by many researchers that a new jail was built nearby, perhaps on lot 63 Old Town, at the corner of Turner and Ann. New bounds in 1800 would make this a viable option. These areas included the waterfront on the south between Craven and Orange Streets, both of those two streets and Ann Street and also between Craven and Orange. Neither the bounds of 1766 nor this one gave any specifications as to size or acreage.

The next courthouse and jail buildings were constructed on Courthouse Square lots during the building of Fort Macon.

BUILDING THE SECOND CENTURY

COURTS, CRIME AND PUNISHMENT II

The new courthouse, at the intersection of Turner and Ann Streets facing south, was approximately twenty-four feet long by twenty-three feet wide, nearly square. The doorway was forty inches wide facing south toward the harbor. There were two windows on each side, none at the end opposite the doorway. Each window was thirty inches wide. A set of stairs to the second floor was in the western front corner, enclosed with a doorway at the bottom. The bar separating the court figures, attorneys, jury and plaintiff was approximately halfway into the room. Benches and tables as well as the justices' table and chairs were behind the bar. The building was placed on ballast stone piers, covered with whitewash. Shutters were attached to the windows on one side, which made it possible to close off the entire window during storms or in the months when the court was not in session. The interior walls were plaster with whitewash, while the exterior was Spanish brown.

Throughout the early part of the 1800s various clerks were ordered to keep the keys to the new courthouse so that it would not be used for anything other than that for which it was built, and to keep their books and registers in a small corner office as well. Tar and Spanish brown paint were provided to paint the building's exterior along with the new jail. Within ten years, the courthouse needed repairs and alterations in the bar. In the ensuing years, items necessary for the operation of the court were purchased, including candlesticks, a bookcase, a small desk, a chest to hold the old papers and a bound book for the court minutes.

In 1807 commissioners were appointed to examine and report what part of the registers' books needed to be transcribed. David Ward was appointed to do the first five books, A, B, C, D and F. These are the same books used in research at the register of deeds office today. A through E are all-inclusive, with F coming along by itself. The original books have been microfilmed and printouts made that preserve the Ward copies.

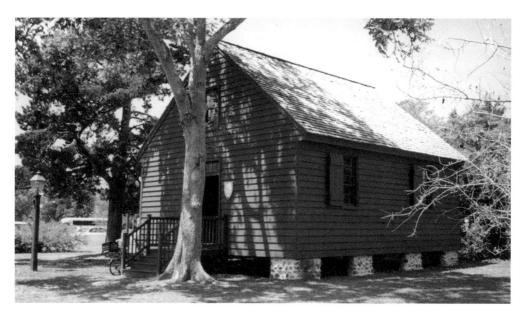

1796 courthouse on BHA restoration grounds. *Courtesy of the author.*

The year 1809 saw the change in meeting months by an act of the assembly. Originally the court met on the third Monday in February, May, August and November. The new schedule was to meet the first Monday of March, June, September and December. A conflict occurred first thing as the March session was to meet. The Superior Court was in session, so the Court of Pleas and Quarter Sessions had to move to the former courthouse/church building down the street. The same problem occurred in the September meeting. Belcher Fuller was appointed in March 1810 to drain and fill the water holes under and around the courthouse. In September, George Read was paid for repairing the windows and building a small office room inside the courthouse. Once again, Superior Court was in session in the new courthouse, so the lower court adjourned until the next day. Repairs to the building and fixing the holes in the roads continued over the next few years, until finally in 1832 the decision was made to build another new courthouse on lot 128 Old Town on Courthouse Square.

The commissioners were ordered to sell and move the old courthouse once the new one was built. This was done in 1837. The 1796 courthouse was moved to the corner lot, number 72 Old Town, adjacent to or near the old courthouse/church building on the same lot. It was sold for $170 in 1843 to George W. Denby, and in 1844 Dr. James W. Hunt, a county commissioner and surgeon during the War of 1812, purchased the house for $425. His heir, Stephen, sold the house and one-fourth of the lot to Dr. William Cramer for $325. His granddaughter was still occupying the house in 1966.

The 1796 courthouse, known then as the Cramer/Thomas house, was purchased by the Beaufort Historic Association in the 1970s and moved to the grounds, where it held exhibits of items donated to the association regarding the courts. In 1997, following extensive research both physically in and under the house as well as paperwork and

writing, the decision was made to completely restore the house to its original glory as the 1796 courthouse. Members of the State Archives & History, a courthouse historian from Williamsburg and others, including the restoration specialist Jim Howland and myself, spent many hours reading the building. Fundraising by many members of the association was foremost and well done. Meticulous minutes and notes were transcribed of each meeting held during the process. It was finally determined that this building was the only known eighteenth-century frame courthouse in North Carolina of its size that could be restored.

The courthouse built in 1836–7 was on lot 128 of Courthouse Square, at the corner of Turner and Broad Streets. According to an article by Laura Piner in 1966, Jechonias Pigott, Thomas Marshall, Benjamin Leecraft Jr., James Hunt and George Dill were appointed to superintend and contract for the building. In June 1836, the draft and specifications were paid for as well as having someone clear the lot. James Ward was awarded the contract at $4,400. It has been supposed over the years that Ward hired brick masons to work on this courthouse when they were not building Fort Macon.

The newest courthouse was fifty by sixty feet built of brick with two stories, and walls fifteen inches thick. One entrance faced south on Broad Street and the other faced west on Turner Street. A brick-paved area separated the street from the west side of the courthouse. Inside the west door were the stairs to the second-floor courtroom, which occupied the entire space. The judge's bench was at the north end and there was space for lawyers and witnesses, all enclosed by a rail, similar to the interior of the 1796 courthouse. Long benches were available for spectators.

On the first floor in the southeast corner was the register of deeds office. Two rooms at the north end of the first floor were occupied by the clerk of court and the library. As there was no room for the sheriff in this building, his office was the second floor of the "old marketplace" at the northwest corner of Turner and Front Streets.

Nearly sixty years after the courthouse and the new jail were built, the mortar began crumbling and the fear that the buildings would collapse was allayed by hiring persons to stucco the exterior of both. Thomas Carrow, living in Philadelphia in the early 1900s, wrote letters to Mr. F.C. Salisbury, the county historian, telling him about his experiences of helping to do the stucco work in 1895, being paid seventy-five cents for ten hours of work. He also stated that there were no vaults inside, and old documents were merely laying around. From 1894 to 1898 he helped his father in the register of deeds office, doing a clerk's job of copying deeds and mortgages, issuing marriage licenses, attending court and looking up laws. He also made out vouchers monthly for the poor and indigent.

In 1903, the county commissioners made plans to build a new, larger fireproof courthouse. By 1906, it was a necessity and plans provided for three hundred opera seats outside the bar on the second floor, with fireproof vaults for the register of deeds and clerk of court's offices. This building did provide space for the sheriff. The cost at that time was $32,000, and included a cupola. Located in the center of the Courthouse Square property, it was surrounded by beautiful oak trees and had a curved drive across the front on the Broad Street side. This is the same courthouse one can see today. The additions have been made over the years due to the need for additional county office space.

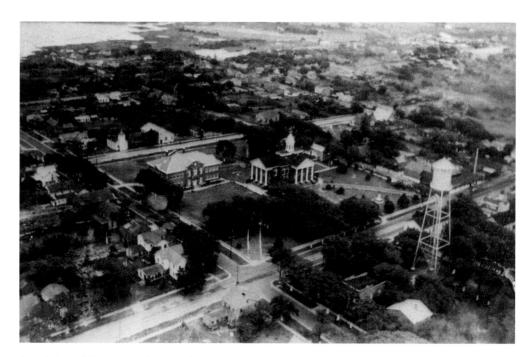

Aerial view of Courthouse Square. *Courtesy of BHA and Ada Hinson.*

The first session of court to be held in the new building was October 19, 1908. The old courthouse was used for a time as a public school and later a library. In 1914 the court ordered the building sold and removed. A year later it was sold at public auction and removed within thirty days. Unfortunately, many of the old books and papers were still in the building when it was demolished, with the exception, luckily, of the two volumes of the registers of the St. John's Parish vestry minutes, which were passed along to the Reverend George W. Lay, rector of St. Paul's Church in Beaufort at the time; he sent them along to the History & Archives of the state, where they remain. Microfilm copies have been made and are available at the local public library. I have copied all pages and transcribed them for use by researchers.

Before the courthouse of 1836 was being built, brick masons were working on Fort Macon. Research shows that the date for building the new courthouse, the new jail and the Odd Fellows Lodge was most likely during the construction of the fort, from 1827 to 1829. As far as the jail is concerned, it was in December 1823 that a committee, including Jechonias Pigott, David Allen and James Manney, was appointed to carry into effect the building of the new jail. Pigott, Manney and others were appointed to contract and draw plans for the new jail in 1824. By December 1828, Elijah Whitehurst was ordered to have until the first Monday in March of 1829 to complete the job! In addition, the next year the treasurer of public buildings was ordered to advertise and sell the old jail, and in the same year the upper walls along the hallway in the new jail were to be walled up and sealed.

The jail of 1829 was built to accommodate the jailer and his family as well as the prisoners. The living quarters on the first floor included the "family room"/kitchen, with

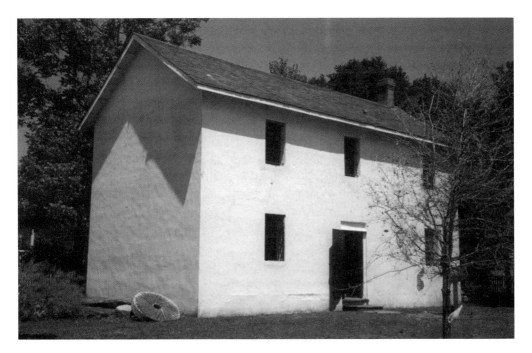

1829 jail. *Courtesy of the author.*

a large fireplace for cooking and heating. On the second floor was the bedroom, with a small fireplace for heat alone. A hall and stairway to the second-floor cells separated the living quarters from the prisoners' cells, both on the first and second floors. It would appear that in the beginning there were two access doors, one that is still intact today. The other, it is believed, went directly into the jailer's side. Access to the second floor for the jailer and his family would have been by a ladder or simple stairs, although no evidence is available of this. In the court minutes from 1829 there is mention of "walling up and sealing the passage plus the upper rooms," which most probably would have been the jailer's side, more than likely for safety. Windows were located in each room, front and back, of both floors as well as at the landing of the stairway.

The jailer and his family made do in a room of twelve feet five inches by sixteen feet on the first floor and thirteen feet five inches by seventeen feet eight inches upstairs. As interpreted today, the family room would have had a table and chairs, kitchen cookery equipment, a desk for the jailer to keep his records in and whale oil lamps or candles for use during the evening hours. The sleeping quarters would most likely have had simple rope beds with lightweight mattresses.

The cells were nearly the same size as the living quarters, being thirteen feet by sixteen feet on the first floor. An entryway door accessed this cell. The second-story cell was thirteen feet nine inches by seventeen feet nine inches. Today there is an access doorway into the room, but research says that the cells were actually wooden with metal straps to make them escape proof. Each of these "holding cells" had no flooring or ceiling, but was built to fit between floor and ceiling. The beams in the attic above are very close

43

together, making it nearly impossible for a prisoner to climb through there and escape. If necessary, one of these "portable" cells could be placed at the top of the stairs as well.

The stairs in the entry hall most likely began nearer the front door, which would have blocked the present-day door into the jailer's quarters. The original stairs were higher than the ones currently in use, and probably were built of wood. Evidence shows that the stairs from the landing area went straight into the upper prisoner side of the second story.

During the 1800s most of the prisoners were "overnighters" having had too much ale or other spirits, or perhaps a difference of opinion with someone else in the county. It wasn't until later in the 1870s that true crimes were committed. In 1870 in Carolina City, to the west of Morehead City, Drummer Hargett and Ann Fisher were charged with the murder of Absalom Fisher. Fisher died immediately from a gunshot wound near his heart. His body was weighted with a piece of iron and chain and dumped in Bogue Sound. A year later, a jury found Hargett guilty of felony murder and Ann Fisher was found guilty of accessory. On February 3, 1871, Hargett was hanged in the jail yard after spending nearly a year in jail.

Another hanging occurred in 1875 within the walls of the jail, according to the sheriff, John D. Davis. Lawyer Bryan was indicted in Onslow County for the murder of an influential citizen from there. His case was transferred to the Carteret County Court, and he to the Carteret County Jail, as it was felt he could not get a fair trial in Onslow. The murder occurred in May 1874 and Bryan was hanged in November 1875. A bill was sent to Onslow County for the cost of the trial and hanging, which included the lumber for the scaffold and coffin, the carpenter's services and the cost of digging the grave, which is, according to records, in St. Paul's Cemetery, potter's field.

The third hanging was the undoing of the sheriff, Mr. Davis. Following the hanging of Edward Foy in the public square of the town of Beaufort, the sheriff went to the court and resigned. Foy had been accused of raping a woman in the Hull's Swamp area of Morehead City in April 1878. He was sentenced twice to be hanged, with an appeal delaying the act, which finally occurred in June 1879.

Twenty years later a murder was committed at Bogue in the western part of the county. Lewis Patrick was accused of breaking into a home and robbing and killing a well-liked merchant of that area. Patrick was arrested and brought to Beaufort to be incarcerated. An incensed group of men became a mob and came to Beaufort by boat during the night, moved through the quiet streets to the jail, convinced the jailer to take the shackles off Patrick and took him back to Bogue, where he was later found lynched. The news of the lynching spread throughout the eastern part of the country, with newspaper articles written in papers across the state as well as in the *Atlanta Constitution*, the *New York Times*, the *Virginian-Pilot* and the *Washington Post*.

After the turn of the century, in 1902, the county commissioners hired a local person to build a jailer's house next door to the jail so that the former jailer's quarters could be utilized as cells. In order to move the portable cells from one of the rooms to the other, as necessary, doorways were cut in the interior walls up and down for access to the former jailer's quarters. The exterior door that once let the jailer and his family into their quarters was bricked up and restuccoed.

In the height of the Depression in the mid-1930s, President Roosevelt and Congress devised a way to put people to work: the WPA. From records furnished to the Beaufort Historical Association, it is discovered that the work in the old jail included pouring a concrete floor on the second story of the building, installing new steel doors and windows with bars and building the wall between the hallway and cell room on the second floor. As with most old buildings, this one being over one hundred years old, there was always work to be done fixing bricks, reslating the roof, taking off the full-length porch, adding a stoop over the entryway and redoing the stucco, among other things. And of course, with changing the way of heating the entire building, not just the family, the advent of electric lights and running water and other modern facilities added to the need for more maintenance.

The last use of this wonderful, old jail, finished by 1829, was in the mid-1950s by an "overnighter" who had imbibed a bit too much. What a fitting end. Following the last stay in the jail, the Women's Club of Beaufort began using the building as a museum. By 1976, the Beaufort Historic Association purchased the building and moved it to the historic grounds to join the courthouse of 1796 and other structures that had been saved and moved there as well. Both the 1796 courthouse and the old jail are open for tours.

Mills, Milling and Lumber

The first sawmills in the United States were in Jamestown, Virginia, and Berwick, Maine, modeled after the European type of mill employing water power and a single sash-saw. Production was small until steam power replaced the water power mills in about 1850. It was about this time as well that the single sash-saw gave way to the circular saw, which was used until the late 1800s, when the band saw became popular.

Water-powered sawmills were situated on rivers and streams where logs could be floated or rafted to the mill. Waterborne logs were floated from a pond over an inclined chute or log slip into the head of the mill and dragged out by a winch. This was the case in the early mills in Carteret County, primarily in the Mill Creek and Core Creek area, where mills were located along the Newport River and streams leading to it. William Borden and his wife and family came to this area from Newport, Rhode Island, in 1732. They settled in the area known today as Mill Creek and built ships. Prior to Borden's arrival, Henry Stanton and his family had come to this area. Both families were Quakers, and both men were shipbuilders. Their wives were sisters.

In the mid-1800s, the new type of steam sawmill was built in Beaufort. In 1843, William Jackson Potter, a brick mason who came to the area to work on the fort, had purchased two lots on the water at the west end of the town from the widow of Daniel Piver. These lots had been formed earlier in the century by the dredging of a channel within the marsh purchased by Daniel's father in the mid-1700s. It was also at that time that Piver's Island was formed from the westernmost marsh.

William Jackson Potter had purchased lots 121 and 122 in 1838, along with Lot 41 Old Town, where Peter Piver had built the home that Daniel had inherited. When he

sold the northernmost lot, 122 Old Town, in June 1843 to Benjamin Leecraft, Thomas Duncan, Malachi B. Roberson and William C. Bell, it was still marshland. A month later, the same four gentlemen purchased from Isaac Hellen the rocks, land and marsh abutting lot 122 Old Town. Earlier in June, Mary W. Davis had sold a part of lot 45 Old Town to the four men. At this point begins the amazing exchange of deeds within the ownership of this property.

In 1850, William C. Bell wrote his will with Benjamin Leecraft Perry as his executor. Perry handled the sale of all Bell's properties, including that of the westernmost portion of lot 45 Old Town and all of lot 122 Old Town, including the rocks and land. It is within the deed from Perry to the other three men who were involved in the former purchase that a mill is mentioned. Three-fourths of the land, with the sawmill and acres in Newport fork, plus a slave, were sold at public sale for nearly $6,000. In March of the next year, Roberson, Duncan and Perry, the remaining partners in a firm known as B.L. Perry and Company, placed the property for sale to the highest bidder in order to dissolve the partnership and pay off the debts. Benjamin Leecraft Jr. was the last and highest bidder.

The deed described the property purchased for $8,556 by Benjamin Leecraft Jr. as lot 122 lands, rocks and marsh; one-third of lot 45; the steam saw and gristmill; fixtures, engines, wharves, tools and other things appertaining to the lots; all timber, lumber, plank, scantling and other material on hand or sawed or purchased for on account of said mill; a slave man, Henry, age twenty-seven; a canoe; a sulky and harness; and eighty-seven acres, one hundred acres, four hundred acres and five hundred acres, all in the forks of the Newport River. On the same day, Benjamin Jr. sold the lands and three-fourths of the sawmill and appurtenances, acreage and Henry, etc., back to Thomas Duncan, M.B. Roberson and Benjamin L. Perry for a bit more than $6,000. The two deeds were not registered until 1869 and 1870.

The sawmill and the surrounding property were used over the next several years to provide lumber and other materials to builders for the construction of many of the homes and churches built in the 1850s and 1860s. In 1866, Benjamin L. Perry Sr. wrote his will leaving his waterfront property to his sons, Benjamin L. Jr. and John M., and all other to his wife, Elizabeth V. Perry. The property, valued at $15,000, was to be sold to pay the debts. Benjamin L. Perry Sr. died in 1869.

In the year 1866, on December 15, Lunt Brothers—a company from New York— "purchased" from B.L. Perry and Louis Davis the steam sawmill at Beaufort, as it stood, and all the property on or about the premises, plus the South River land connected to it. The "sale" included the lease, the wharf, engines, carlers, machinery, fixtures, tools and implements appurtenant to the sawmill and also all other personal property connected to the mill such as blacksmith's forges, tools, axes, timber track, chains, fastenings, cooking utensils and office furniture.

Apparently this was a financial deal only, a loan perhaps, for on the same date, December 15, the Lunt Brothers sold the sawmill back to B.L. Perry and Louis Davis from St. Mary's, Georgia. This included the steam sawmill at Beaufort as it stood and all the property on or about the premises and at South River, together with the lease and

interest in the firm, the land and wharf, all engines and other equipment on the property. A year later, Benjamin L. Perry paid half the amount to Louis Davis to buy him out.

The deed of sale from the Lunt Brothers to Perry and Davis was registered in 1879, a month after Perry's will was probated. Another deed written in 1867 shows that he had sold, for $1,000, half the steam mill on lot 122 with half the fixtures, buildings, furniture, etc. to Thomas Duncan. This deed was registered in 1869. Even more confusing is the fact that apparently Benjamin L. Perry owned all the property originally purchased in 1843 on which the steam saw and gristmill were built.

In 1870, Benjamin L. Perry Sr. died, and his son, Benjamin L. Perry Jr., and wife Susan, living in Lincoln County, North Carolina, sold one-fourth of the right, title and interest in the steam mill property belonging to the former firm of Benjamin L. Perry & Co., now known as Duncan & Perry. This did not include the acres in Newport River, the black man, canoe, sulky and harness, which were sold to Thomas Duncan for $200. It is presumed that M.B. Roberson was at that time deceased, thus Thomas Duncan became the outright owner of the mill property.

Not necessarily so! For in 1871, Benjamin L. Perry sold to Thomas Duncan, for $4,200, one-fourth undivided portion of the steam saw and gristmill with box machine and other things belonging, including a box of hooks, one-fourth of the lumber and timber, one-fourth of a yawl boat, one yoke of oxen, two pairs of carry logs and other goods and chattels formerly belonging to the firm of Duncan & Perry. No mention of the land or lots was made in this deed. But apparently Thomas Duncan then owned lot 122 with all the lands, rocks and marsh as well as one-third of lot 45, one-fourth of lot 42 and the sawmill and all that went with it, renamed Duncan & Bros., plus many other lots in town.

In 1878, Thomas Duncan wrote his will leaving to each son, William B. Duncan, Thomas L. Duncan and John A. Duncan, one-third of lot 122, lot 43, the sawmill and fixtures. There is no mention of lot 45 in this deed. Thomas Duncan died in 1880. When John A. Duncan wrote his will in 1920, he was living in Raleigh and there was no mention of any land in Beaufort. Thomas Lucas Duncan had remained in Beaufort, as had William Benjamin Duncan, who lived in the Duncan house at the west end of Front Street.

William Benjamin Duncan was married twice—first to Sarah Ann (Sally) Ramsey and later to Emily Frances Jones. From his first marriage came children Charles, William Ernest, Isaac Ramsey, Thomas L., Edward Carl and Graham Washington. Children from the second marriage included John Francis, David J., Emily Estelle, Sarah Elizabeth, Julius Fletcher, James Shepard and Lillian.

Thomas Lucas Duncan married Annie Leecraft and had five children, two of whom were living when their grandfather died in 1880. Their mother died in childbirth in 1877 and four days after the death of their grandfather in 1880, their father died. The two surviving children were Charles Lucas Duncan Jr. and William B. Duncan Jr. They became wards of their uncle, William Benjamin Duncan. Their cousin, and son of W.B. and Sally, Thomas L. Duncan became a commissioner of the town and was appointed to sell the property left by their grandfather.

Thus in 1885, Thomas L. Duncan sold to W.B. Duncan the lands of Thomas Duncan, deceased, for partition between W.B. Duncan, John A. Duncan and Thomas Lucas Duncan's sons, Charles Lucas and W.B. Duncan Jr. This included all the tracts of land, the steam mill and site on lot 122, along with parts of lots 42, 43 and 45. This deed was registered in 1903. On the same date in 1885, William B. Duncan and his second wife, Emily F., deeded their undivided half of the property to John A. Duncan.

The final outcome of all this transfer of the steam saw and gristmill property, which had begun in 1843, was that half the property was in the hands of William B. Duncan for his wards and nephews, Charles Lucas Duncan Jr., William Benjamin Duncan Jr. and John A. Duncan, who was living in Raleigh.

By the early 1890s the A.G. Hall shipyard was along Gallant's Channel, next to a packing company. By 1898, the packing company was gone and in its place was the W.E. Perry saw and gristmill. In addition, the Beaufort Lumber Company had begun operation at Lennoxville, three miles east of Beaufort. This mill, according to the 1898 Sanborn Map, had a log basin, the sawmill and a tram that took the lumber to the steam dry kiln. Apparently over the next few years, along the channel appeared the W.V. Geffroy boat building company and a new packing company next door. By 1913, the packing company was still in place, but there was a new wood yard north of it owned by J.C. Beveridge and the Penn Lumber Company Saw Mill was located in the Lennoxville area, perhaps having taken over the Beaufort Lumber Company.

Other lumber companies were also in the Beaufort area in the early twentieth century, among them Safrit Lumber Company, which was located near the waterfront of Taylor's Creek. The Safrit family continues in the lumber business today, operating a store on Lennoxville Road, although without the sawmill. Another mill was located along Town Creek where today is a low-cost housing project built following the extension of Turner Street across Town Creek to West Beaufort Road. Today in Beaufort is the plant of Atlantic Veneer, where lumber is brought in from South America and other parts of the world and turned into large sheets of veneer.

Mills, milling and lumber have been a major part in the growth of the town of Beaufort over the past centuries.

RELIGION AND HOUSES OF WORSHIP

Two of the historic churches in Beaufort, built in the mid-1850s, surround the Old Burying Ground. One is on lot 101 Old Town at the corner of Craven and Broad Streets and the other is on lot 71 Old Town at the corner of Craven and Ann Streets. A third church is located nearby on lot 72 Old Town, near the corner of Turner and Ann Streets. The historic Episcopal church is located in the middle of the second block of Ann Street.

Ann Street Methodist Church. *Courtesy of the author.*

CHURCH OF ENGLAND

At the beginning of the town in the early 1700s, religion was a must for all who lived here. Persons were automatically members of the Church of England and worshipped throughout the eighteenth century in the church/courthouse in Beaufort or in one of the chapels built in some of the other populated areas of the county. Following the Revolution, when the new Anglican church was being built to replace the combination church/courthouse, the Church of England was no longer in favor. Thus the new structure, on lot 101 Old Town, was taken over and completed by the Methodists, some of whom may have been Anglicans before the Revolution. In 1820 they received the deed for this lot and the building that today is known as Purvis Chapel AME Zion.

METHODISTS

The Methodists continued to use the former Anglican building until the mid-1850s, when it was deemed to be too small to accommodate all the people who worshipped in the church, including the black families who were associated with the whites. Thus, the first Methodist church building was erected on lot 71 Old Town, where it remains to this day. In the late 1800s the building was remodeled to include an addition for Sunday school. While the remodeling was taking place, the minister became ill and work stopped. The next minister came and found the windows boarded up and Methodists

worshipping where they could. With this preacher's enthusiasm and leadership, donations were rounded up and the building began anew.

Ann Street Methodist Church has grown over the years, with many beloved ministers. One in particular was the Reverend John Jones, son of Captain John and Sarah Fisher Jones. It is said that the Reverend John Jones held the church together during the Civil War. The Reverend Jones married Susan J. Bell, daughter of William and Elizabeth Howard Bell. The children of this marriage have all been involved in the growth of Beaufort, and most of the family burials are in the Old Burying Ground, which surrounds the church.

When the new Ann Street United Methodist Church was completed, the old building was given as a gift to the black members of the congregation. After a popular revivalist minister, Reverend James Purvis, visited in 1834, the old church was named Purvis Chapel. It is said that he led a "soul-stirring revival" during his visit and folks stayed all night long to hear him preach. It wasn't until 1916 that the final separation took place. On December 18, the officials of Ann Street Methodist Church deeded the chapel to its trustees and Purvis Chapel joined the North Carolina Conference of the AME Zion Church.

PURVIS CHAPEL AME ZION

Over the years this church, located atop the original piers of the 1728 courthouse/ Anglican church building on lot 101 Old Town, has grown in membership and changes have taken place to the building itself. The south tower was taken down and the "slave" gallery in the nave was removed. But, in essence, the building is still that which was begun in 1774 and enlarged in 1820. An onsite survey was completed in 1996 with Jim Howland, a restoration specialist, and John Costlow, a local preservationist, crawling underneath the chapel, where they discovered the original piers of 1728 and earlier. The present building was expanded both in width and length on new piers. At a later date, Jim and I were allowed to climb into the attic and the former bell towers to see what was left of the original construction.

As shown in a drawing of the church circa 1900, the church had two towers, with an entrance in each. The taller tower housed the 1798 bell. It was, however, in 1820 that the front towers were added, making the entryways protected. By 1920, the upper part of the south tower had been removed, although remnants of it can still be seen from inside. A central access door and windows were placed between where the towers stood in the original front wall. An extension was added to the rear of the building, the upper windows along the sides were removed and the lower ones were replaced. The bell that hung in the north tower now resides inside the church. Purvis Chapel is an active and prospering church of the historic black community.

BAPTISTS

The other church to be opened in the mid-1850s adjacent to the Old Burying Ground was in the old courthouse/church structure, which had been moved in 1774 to

Purvis Chapel AME Zion Church. *Courtesy of the author.*

accommodate the erection of the new Anglican church. The building was placed on the western edge of the Old Burying Ground in the eastern part of lot 72 Old Town. It continued to be used as a courthouse at times until the Baptists organized as a body in 1851, with charter members James G. Noe, Mary Noe, George D. Anderson, Jane Anderson, Asa Piver, Naomi Piver and Jane Sherwood.

Services were held in the old courthouse building as well as the Odd Fellows Hall and the home of James G. Noe. A building committee was appointed, consisting of William J. Potter, Joel H. Davis and William F. Bell. William J. Potter was the brick mason who came in 1829 to work on the fort. Joel H. Davis was a son of James Davis, one of the more prolific builders in the community. William F. Bell may have been the son of Josiah Bell and Mary Fisher Bell. A new church as such was not built at the time, but the courthouse building was modified with an entry tower and spire and may have been enlarged to accommodate the growing number of members of this church. The church was taken over by Federal soldiers during the Civil War and greatly damaged due to the various uses it was put through.

The present-day brick sanctuary was completed nearly one hundred years later in the middle of lot 72. Additions were made in 1956 and the education building was added in 1960. A new parsonage was built in the 1970s. The members of this church are dedicated and loyal to their ministries, which are many.

EPISCOPAL

St. Paul's Episcopal Church is the descendant of the old St. John's Parish of the 1700s. Since the Revolution was against England, it was advisable that, in many cases, the vestry members

First Baptist Church. *Courtesy of the author.*

and wardens of the Anglican church should change their titles to the wardens of the poor. They continued caring for the poor, downtrodden, sick and dying until 1843. A poorhouse was established and funds were made available by the town and county to help those in need. The former Anglicans most likely began worshiping at the Methodist church.

In September 1855, a young, enthusiastic, fairly new priest of the Episcopal Church came to Beaufort and organized the new Episcopal church. William J. Potter, Isaac Ramsey, Robert E. Walker, James J. Whitehurst, Samuel S. and Elizabeth F. Duffy, Josephine A. Jones, William Cramer, D.B.L. Bell, J.B. Moore and Carolina S. Pool made up the requisite number of persons. The first vestry consisted of Mr. Duffy and Mr. Ramsey, most likely as wardens, although not named so in volume one of the records; Mr. Cramer as secretary; and Mr. Potter as treasurer.

As there was no building at all, Mr. Stephen Decatur Pool offered his academy on Turner Street for services. By December the Baptist house of worship was retained and used until they obtained a minister in the beginning of 1857. The new courthouse was then used until St. Paul's had its very own church building completed enough to allow the congregation to gather for worship services. A Sunday school was organized and a melodeon was purchased.

A lot in the middle of the second block, on the north side, between Moore and Orange Streets was purchased and construction began in the spring of 1857. Using the design of Richard Upchurch, Mr. Van Antwerp engaged ship carpenters to build the

edifice, which is nearly unchanged today. The building was completed in November 1857 and has been used since that time by the growing numbers of Episcopalians who live in Beaufort and Carteret County.

In 1887, a lot at the corner of Craven and Cedar Streets was sold to the Trustees of the Diocese of East Carolina at Wilmington, and paid by Trustees of St. Clement's Episcopal Mission (colored), to build a church for the black people who preferred to worship in the Episcopal way. Prior to the mission church being erected, they had been worshiping at St. Paul's. Due to lack of attendance and the trouble of upkeep of the building, the mission church was closed in May 1967 with the urging of the then-bishop that members of the colored parish should join with those of St. Paul's, as their ancestors had done before 1887. St. Clement's Mission stood for nearly eighty years as a member of the Episcopal community.

St. Paul's Episcopal Church is in the midst of celebrating the 150 years that the parish has served its communicants and others. Beginning in 2005, former priests have returned to regale the audiences with their memories of time served as the rector of the parish. Members of the parish who have been active in the Sunday school, as well as former vestry members, have also spoken. Most of the events throughout the 2005–06 span have been videotaped and audiotaped and will be included in the history of the church that I am writing. In November 2007 we will end the celebration with our bishop visiting to reconsecrate the building, the cemetery and other items that have been given over the 150 years.

CONGREGATIONAL

After the Civil War, Reconstruction was long and tedious under the domination of the Yankee "conquerors." One of the positive sides to this, however, was the work of the American Missionary Association, which had been established in 1846 by the Congregational Church. It was the goal of the association to build schools or seminaries in the South that would educate and train the freed slaves. At the same time, a Congregational church would be built as well. Over five hundred schools were established and built across the country.

St. Stephen's Congregation Church was built on the western end of the lot facing Craven Street, next to Washburn Male & Female Seminary, where it remains today. According to newspaper reports, there were many activities for the congregation to participate in, such as hosting a group from New Bern, speech making at the seminary, walking about the streets and listening to the band that accompanied them. In 1882, it was reported that the Nightingale Minstrels were coming to town to perform at the seminary. In 1887, there was a meeting of folks to make arrangements for the celebration of the Emancipation Proclamation on January 20, 1888.

In 1986, an interview with Annie Parker told of her recollections as a student at the seminary and of becoming a member of the Congregational Church after a fallout occurred with some Presbyterian members. Some of the members of the church included Annie, her two daughters, as well as Abe Thurman and Katie Jones. Some of

St. Paul's Episcopal Church. *Courtesy of the author.*

the pastors of the church included Michael Jerkins and a Mr. Simms, who served for many years as the pastor of the church as well as principal of the seminary. In 1917 he became seriously ill and resigned.

MEDICINE, DOCTORS AND DRUGS

A town cannot actually survive life without having a doctor, dentist or pharmacist to take care of the folks who live there. The same is true in Beaufort. Medicine here and throughout the state and the country has come a long way since the early 1800s when the first medical doctor arrived. Dr. John Poythress was legally appointed the port physician for Beaufort. He advertised in the *Raleigh Star* about the opening of a private infirmary. But, having died later in the year, his dream went with him.

PHYSICIANS

Dr. James L. Manney and his wife, Maria, left New York in 1809 to come south. After a brief stopover in New Bern, they continued to Beaufort, where he became very interested in the growth of the town and surrounding county. Dr. Manney was born in Poughkeepsie, New York, in 1785 and died in Beaufort in 1852. He married Maria F. Lente, who was born in New York City in 1791 and died in Beaufort in 1864.

The Manneys had one son, James L. Manney, born in Beaufort in 1827 and died in 1889. He also became a doctor and served during the Civil War. Another son was born in 1823 and lived only eight months. James Jr.'s sister, Nancy L. Manney, was born in

1820, the oldest child of James and Maria. At some point in her life, a tutor came to Beaufort and when they met it was love. Her father discouraged her romance because he wanted her to stay here and take care of the younger siblings. According to the legend, Mr. French, the tutor, left Beaufort and moved to Arizona Territory, where he became a chief Supreme Court justice of the territory. He wrote Nancy often, but her father had the letters intercepted by the postmaster, who confessed what he had done before he died. It wasn't until the mid-1880s that the two would be together, but only for a short time, as she died in 1886 of consumption in the arms of her new husband.

Dr. Manney purchased five lots in town in 1812. He was elected a commissioner in 1815 and served one year, and was also appointed as treasurer. In 1817, Manney purchased additional property at public auction and continued to serve as a commissioner. He also served as the collector of customs of the port from 1819 to 1829, and established a brick-making plant and a saltworks.

In 1823 James Manney was appointed clerk to the Board of Commissioners, and by 1824 he was elected a commissioner and appointed intendant of police. In 1826 Dr. Manney listed eight lots in Old Town in the tax evaluation. Again in 1827 he is shown as possessing eight lots in Old Town. By 1828, Manney is listed as owning the eight lots and a store in the tax evaluation. Manney's lots increased by one during the 1829 evaluation and he purchased yet another. In 1830 he purchased another lot in Old Town. The 1830 evaluation shows him owning ten lots.

In 1832, Manney was allowed funds for the medical attendance to the poor, and in 1841 he was paid for visiting prisoners and dosing them with calomel, doctoring two from a Peruvian bark and paying a visit to Jordan's wife, who died suddenly.

In the *Halcyon and Beaufort Intelligencer* of 1854, it was announced that James L. Manney Jr., MD, had joined in a partnership with M.F. Arendell in the practice of medicine at number 9 Turner Street, across from the market. In 1861, Manney Jr. enlisted in the Beaufort Harbor Guards, a local Confederate battery. He was at Fort Macon a year later when the Yankees captured the fort. Throughout the remainder of the war he helped build pontoon bridges and boats in the eastern part of the state and part of Virginia. He was released in 1865 and returned to Beaufort, where he reestablished his medical practice. He continued the practice until his death in 1889.

In 1824, a new physician appeared in Beaufort, Dr. James W. Hunt, who had been a surgeon with the U.S. Army during the War of 1812. Dr. Hunt served as a justice of the peace and was also appointed clerk of the Board of Commissioners. Hunt was elected in 1825 as a commissioner while continuing to serve as clerk. According to the town records, Dr. Hunt lists one lot in Old Town in the tax evaluation of 1826. In 1827 he shows a different lot in Old Town as his. In 1828, as a justice of the peace, he qualified the next group to be elected as commissioners, and he lists still another lot as his. By 1829, it appears that Dr. Hunt owned two lots in Old Town. By 1830, there is only one lot listed for him in the evaluation.

Dr. J.S. Hellen appeared on the scene in 1830 and was paid $8.75 for his services as health physician and for vaccinating the poor of the town. In the evaluation of 1830, he lists only himself as a poll. Other doctors in Beaufort included Frances L. King, Cicero

Hill and Michael F. Arendell, as well as Josiah Benjamin Davis and his son, George, Joshua Judson Davis, Charles L. Duncan and Dr. Hyde. In the census of 1850 there were four doctors living in Beaufort.

Michael F. Arendell, MD, is listed in the 1870 census as being fifty-one years old and living with William and Sarah Arendell, perhaps his brother and wife. Other physicians or pharmacists listed in the census of 1870 included Allen Davis, thirty-five with an apothecary; and doctors Abraham Congleton, seventy-two; Francis King, sixty-four; Robert Walker, thirty-six; James Perry, thirty; Lafayette Martin, forty-five; James Manney, forty-two; and Benjamin Davis, thirty-eight.

Francis Lathrop King, the only child of Joseph and Mary Catherine Cumberlowe King, was born in the early 1800s in Edenton, North Carolina. Prior to moving back to Beaufort in 1819, he had attended New York's Bellevue Hospital for physician's training and received his diploma. After settling back in Beaufort, he began his practice along with a drugstore on Front Street. He married a local Beaufort girl, Sara R. Ward, and they had ten children, two of whom followed in their father's footsteps, becoming physicians. One practiced at Bellevue Hospital in New York while the other was a well-known and beloved doctor in Wilmington, North Carolina.

Dr. Josiah Benjamin Davis, son of Allen and Mary Jane Simpson Davis, was born in August 1831. At age thirty-one he was a laborer in a local shipyard and later taught school. By the late 1850s his interest turned to medicine. He attended his first course of lectures and in 1862 began his practice. For two years he operated a mercantile business, then took a second course of lectures and graduated from New York City College in 1865. On his return to Beaufort he married Mary Ann Sewell. He continued his practice as a physician and was also a leading druggist in town. He died in 1902 and Mary Ann died in 1921.

Josiah Benjamin and Mary Ann Sewell Davis had four children. One, George Davis, was born in 1874. He studied at several colleges, including Wake Forest, Louisville Medical College, Richmond Medical College, the University of Chicago and did postgraduate work at Columbia University in New York City. George Davis began practicing medicine in the 1890s and was an assistant to the physician in charge of the state hospital in Raleigh. While there, he met the doctor's daughter, fell in love and became engaged. The engagement didn't last for some reason, and Dr. George returned to Beaufort to practice medicine with his father. In 1895 it is said he wrote a pharmacy textbook.

After his father's death, Dr. George continued actively practicing medicine until retiring in 1916–17. He apparently did continue to treat and advise patients from the drugstore until his death. He never married, and took care of his mother in her final years. In 1937 he died in the Chadwick House of Hodgkin's disease.

Dr. Joshua Judson Davis and his wife, with their eleven children and all their possessions, sailed into Beaufort, landing at Howland Rock on North River in 1910. The doctor grew up near Elizabeth City and studied medicine with a local doctor. He then attended both the University of Virginia Medical School and the University of Maryland Medical School in Baltimore. He received his medical degree and in 1891 was licensed to practice in North Carolina. After arriving in Beaufort, he set up his medical practice. In 1922 he moved his practice to Smyrna, where he lived until his death in 1949.

Dr. C.L. Duncan and family. *Courtesy of Virginia Duncan Costlow.*

Charles Lucas Duncan was born in 1872 to Thomas Lucas Duncan—son of Thomas and Elicia Howland Duncan—and Ann Leecraft Perry Duncan—daughter of Captain Benjamin Perry and Ann Leecraft Perry. His mother died in childbirth when he was five, and his father died in 1880 when he was only eight. He and his brother William became wards of their uncle, William Benjamin Duncan. William left Beaufort and worked on the railroad that was connecting eastern and western North Carolina. He died of typhoid fever in 1892.

Charles left to attend Trinity College, now Duke University, to study civil engineering. Stunned by his brother's death, he changed his studies to medicine and entered the University of North Carolina at Chapel Hill, where in 1900 he received his certificate of medicine. While in Chapel Hill, he met his wife, Virginia Clyde Mason. They went to Baltimore, Maryland, and two years later, in 1902, he received his doctor of medicine degree and returned to Beaufort. He was well known in town and across the state dealing especially with children's disease. Dr. Duncan had a practice and a drugstore on Front Street.

In 1918, after taking care of the needs of Carteret County citizens during the flu epidemic, he suffered a stroke at age forty-six. Another stroke in 1925 ended his physician's career. With a need to provide for his family and educate his three daughters, he turned to his engineering training and formed the Coast Construction Company in 1927. He had purchased a dredge boat known as the *Neverrest* and obtained the contract to build the causeway between Morehead City and Beaufort. Twenty years earlier, using an old bucket dredge, he and William Shull had laid the roadbed across the Newport marshes for the first train tracks to bring the train to Beaufort.

Bell's Drug Store today. *By Diane Hardy.*

After eight more years of dredging, in part the inland waterway, his health declined and in 1935 he sold the *Neverrest* to a company out of Norfolk. He died in 1937 at age sixty-five. Dr. Duncan and his family were members of St. Paul's Church, and his three daughters attended St. Mary's School in Raleigh, followed by graduation from the University of North Carolina at Chapel Hill. Dr. Duncan's children are gone now, but two of his granddaughters, Virginia Duncan Costlow and Margaret Herrmann Midyette, as well as Virginia's son and grandson, live in Beaufort today.

APOTHECARIES AND DRUGSTORES

Drugstores in today's fast-paced life are a necessity and we see more and more the chain drugstores across the country. Even today in Beaufort we have two of these, Eckerd Pharmacy and CVS, with a Walgreens being built in Morehead City. There are few locally owned drugstores any more. One of these is Bells, at the northwest corner of Turner and Front Streets. The story of this shop is an interesting one, and begins with Dr. Charles L. Duncan.

Dr. Duncan opened his practice of medicine in a building at the northeast corner of Turner and Front Streets. In addition to being a physician, he also formed the Beaufort Drug Company. A young lad named Frank Roland Bell from Elizabeth City came to Beaufort in the late 1800s, where he obtained a job in 1910 as a clerk at the Beaufort Drug Company store. He attended pharmacy school beginning in 1912 and returned to the store a year later, where he continued to serve the public until joining the medical corps during the First World War.

The apothecary and doctor's office on the restoration grounds of the BHA. *Courtesy of the author.*

In 1919, on his return from the war, Bell began his own F.R. Bell drugstore in Beaufort, replacing the Beaufort Drug Company, which had closed after Dr. Duncan's massive stroke in 1918. Plagued by illness in the 1920s, Mr. Bell joined in a partnership with Ivey Guthrie, changing the name of the store to Guthrie-Bell, located in the 400 block of Front Street. During the years that followed there were many clerks and pharmacists working at Guthrie-Bell Drug Store. Clarence Guthrie was one, and he with another, David Jones, formed Guthrie-Jones Drug Store, which was sold to Eckerd in 1980.

The Guthrie-Bell Drug Store was sold in 1969 and the name became Bell's Drug Store—the very same one that is at the northwest corner of Turner and Front Streets. The original store remained on the south side of Front Street until 1974, when urban renewal demolished the old buildings on the water side in the 400 and 500 blocks of Front Street. No longer can you get ice cream or homemade sandwiches. But Bell's Drug Store is the only "downtown" drugstore in operation today, serving the needs of locals and visitors alike.

The history of the other drugstore, or apothecary, begins in 1859, when it was built by Dr. Josiah Benjamin Davis next to his home on Ann Street in the 400 block. Legend says that the apothecary was originally located between the former courthouse on lot 72 Old Town and the old Baptist church. In Gray's map of circa 1880 it appears to be across the street, next to his son's house. Most likely when Dr. George began practicing medicine alone, the apothecary shop had his doctor's office in the rear. After his semi-retirement in 1916–17, he continued to serve his patients and others until his death in 1937. Thus the apothecary shop was used for nearly seventy years.

In 1974 the building was moved to the grounds of the Beaufort Historic Association. The Chadwick family, relations through marriage to the Davis family, gave the building and the Mace family provided funds for the restoration. The flooring and counter were replaced with old wood from buildings being torn down for urban renewal, but the cabinets and shelving are original, as are the old doors with low handles. Many of the items that are in the apothecary shop and the doctor's office came with the building.

A write-up by Jackie Hubbard, the chairman of the apothecary shop at the Beaufort Historic Association, says that Dr. George was of very fair skin with dark hair. He would always wear a long-sleeved shirt when going out late in the afternoon or in the evening. Following the death of his sister, he wore black. Many times in the evenings, he would invite friends to join him in the office to discuss religion, law and politics. An accomplished musician, he could often be heard practicing on the organ in his office between patients' appointments. Following the death of his mother in 1921, he apparently moved to the Chadwick House next door, where he died. A wonderful memoir of Dr. George Davis was written by his niece, Anne Davis Chadwick, in July 1982.

Education and Schools

Colonial Days

The first schools in Beaufort were established through the generosity of Mr. James Winwright in his will in 1744. He willed and appointed the yearly rent and profit from all the property he owned in town with houses and other adjoining lands to be applied by the chairman of the county courts and a warden of St. John's Parish to find a "sober, discreet, quallifyed man" to teach a school of "reading, writing vulgar and decimal arithmetick" in the town. He also gave fifty pounds toward building and finishing a school and dwelling house for the master, to be erected near the White House (Hammock House), which Winwright had purchased earlier. He also stipulated that the master did not have to take under his care any "schooler or schoolers" the trustees might wish him to take. The master was to take so many "schoolers" as he thought convenient. In addition, many of the acres around the house were to be used as farmland available to the master.

There is no absolute mention of the construction of the schoolhouse in the place specified, but there is evidence that it was built. In 1745, there was a school at Straits. In 1756, John Bell of St. John's vestry was authorized to employ a schoolmaster to "keep school two years," including schools at Shepard's Neck, Morehead City today, and Straits. The school year was only three months long. In 1765 the vestry was looking for three schoolteachers. Samuel Leffers, a schoolmaster from New York, came to Beaufort in 1764. He became the schoolteacher in Beaufort and probably in Straits, as in later years he lived there, as did his daughter and several grandchildren who married in Straits and lived there as well.

In 1755, Joseph Bell had given the vestry thirty square yards of land in the present-day Morehead City for the building of a chapel. And in 1761, George Bell gave the vestry two acres of land in Straits for the same purpose. It is presumed that since the vestry of St. John's Parish owned the land and chapels, they would also use the two buildings as schools. The Beaufort school was used in 1782 by the militia to meet and negotiate with the British when they invaded the town. The British burned the schoolhouse on their exit. Mr. Leffers was in control of the schoolhouse property and was schoolmaster the entire time, since in 1790 he was farming the Hammock land. He purchased the property in 1795.

Thus the earliest school system in North Carolina was here in Beaufort and surrounding areas of Carteret County.

PUBLIC SCHOOLS

In the 1930s, Cecil Longest wrote a paper about education in Beaufort for his thesis required for an MA degree in physical education at the University of North Carolina. He received his AB in 1933 and began his teaching career. Portions of his thesis were printed in the *Beaufort News* in September 1942 and used in the Carteret County Historical Research Association's *Heritage of Carteret County*, published in 1982.

In the thesis, Mr. Longest stated that the Beaufort Male and Female Academy was chartered in 1842 with Mr. Langdon as principal in 1856. In 1854–55, the length of the school term was only two months. In 1855, Malachi Roberson had a combination home and school built in the second block of Turner Street. He hired Stephen Decatur Pool to come and teach his children. The school grew into the Beaufort Female Seminary for the instruction of young ladies. He was also approached about teaching young men, and thus opened a night school, as the men's jobs would not allow them to attend school in the daytime. The building in which the Robersons lived and the children attended school is presently the Masonic Lodge.

By 1858 the local editor and proprietor of the *Beaufort Journal* printed a school directory, which included the Beaufort Female Seminary, Mr. and Mrs. S.D. Poole, principals; Beaufort Female Institute, Reverend William J. Langdon, principal; Beaufort Male Academy, Robert W. Chadwick, principal; a male academy kept by a Mr. W.H. Sweetzer; and a primary school kept by Sarah A. Davis.

In 1867, following the War Between the States, the Washburn Male and Female Seminary and St. Stephen's Congregational Church were begun by the American Missionary Association of New York. They purchased the eastern half of lot 150 Old Town, on Cedar Street between Craven and Queen Streets. The western half of the same lot was purchased by a local person and sold to the trustees of the seminary. The deed of 1867 stated that the seminary was established for the purpose of educating colored people.

A survey by Peter Sandbeck in 1995 titled *Beaufort's African-American History and Architecture* speaks about the state of the colored people in Beaufort following the Civil War. The Union occupation of Beaufort gave the area the status of a safe haven for

freedmen or refugee slaves. A refugee camp was established at the north side of town, above Cedar Street. Civil War diaries indicate that newly freed blacks attended night school during the Union occupation to learn to read. Between 1860 and 1870 the black population doubled.

Sandbeck continues that the entire community was built during the late nineteenth century. The construction of buildings such as homes, churches, stores, fraternal lodges and schools was accomplished by black carpenters and builders who constructed simple, small, story-and-a-jump houses. Jobs for many of these people included mullet fishing, working on the large menhaden boats run by several companies, blacksmithing, barbering, cooking, making barrels, brick masonry and baking. By 1895 the Washburn Seminary Trustees purchased the adjacent lot 149 Old Town and erected a building to teach trades such as cabinetmaking, carpentry and blacksmithing.

By 1917, as local school districts began assuming the work of providing more adequate black schools, the association deeded the Blacktown School building to the trustees of the Beaufort Graded School, along with 172 feet of frontage on Cedar Street. It was a black school until it burned in 1920. The town considered rebuilding on the lot, but decided to build the Queen Street School instead. St. Stephen's Congregational Church continues today to serve the families and descendants of those who worshipped there in the beginning.

In 1910 there were forty-one public schools with a term of four months. In 1916, a modern school building was built on Courthouse Square. The term had increased once again to six months. Ten years later, the term was lengthened to eight months. In 1927 the school building was purchased by the county to be used for the board of education. The replacement school was built at the intersection of Live Oak and Mulberry Streets, serving all grades at first, then turned into a high school, followed by a change into an elementary and middle school.

The 1927 school burned in 1945 and was rebuilt on the same lot, where it remains unoccupied today. In the past few years, two new schools have been built on a side road between Highway 101 and Campen Road. The first built was for the middle grades and the second as an elementary school. The high school today is located near the intersection of Highway 70 and Merriman Road, where it serves all students from down east of high school age.

PAROCHIAL SCHOOL

The new rector of St. Paul's Church in 1855, the Reverend Van Antwerp was a promoter of education for all persons, black and white. Following the erection of the church building in 1857, he opened a school in a small building behind the church. His wife, Jane Caroline, with help from Miss Sallie Pasteur and Miss Elizabeth Roberson, were the first teachers. As attendance grew, the school and home of Malachi Roberson was offered by Stephen Decatur Pool for use by the students and staff of the Episcopal school. The school was a prime encouragement to the townsfolk to join the church and have their children attend the school. As the authors of *The Episcopal Church in North Carolina* stated, the school was one of the most effective parochial schools in the diocese.

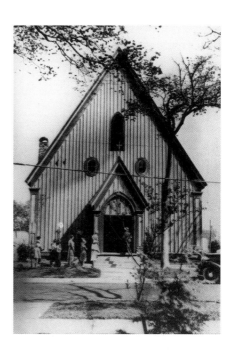

St. Paul's Church, circa 1930. *Courtesy of St. Paul's Church Heritage Committee.*

From 1861 until the end of the War Between the States, the town was occupied by Yankee soldiers. The church and school continued to function, although the classes were primarily those taught in the church, including the creeds, the Lord's Prayer, the ten commandments and the Psalms. In 1865, the Reverend Van Antwerp was ordered as a U.S. chaplain to a hospital in Hilton Head, South Carolina, where he served for two months. Two years later, in 1867, he took his wife and young family out west, as it was drier and not as humid. The school as he had envisioned and started could not continue.

Approximately thirty years later, in 1899, a young local man, having become a priest in the Episcopal Church, came to serve at his home church. With help from Miss Nannie Pasteur Geoffroy, he reorganized and opened the next phase of St. Paul's School. In 1900, a three-story classroom building was built on a lot to the east of the church, and in 1904 Watson Hall, named for the Reverend Alfred A. Watson, former bishop of the Diocese of East Carolina, was built on the west side of the church. Watson Hall served as the dormitory for students coming to school from the Outer Banks and other distant areas. A dining hall was included in the building where all students and staff received hot meals daily.

Miss Nannie Geoffroy was the driving force behind St. Paul's School. During its thirty-eight years as an active parochial school, kindergarten to eleventh grade, the school gained a reputation for quality education. Nannie Geoffroy died in 1937 and there was no one who had her enthusiasm and dedication to continue the school.

After closing, Watson Hall, a magnificent three-story structure, became the parish house of the church used for Sunday school and youth gatherings. In the early 1960s the building was demolished to be replaced by the present-day one-story brick parish

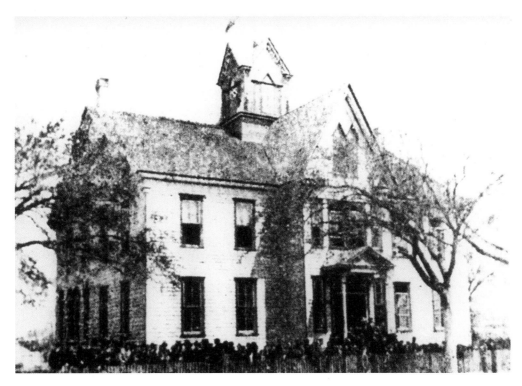

St. Paul's Schoolhouse, circa 1920. *Courtesy of David Clawson.*

house. The school building was also demolished and replaced by a house to be used as a rectory for future priests and their families. In the 1990s the rector purchased his own house outside of town, and this rectory became the offices of the church.

It has been said that if you graduated from St. Paul's School, you could attend any university or U.S. military academy of your choice.

COMMUNITY COLLEGE

Continuing education was also found to be of great importance to the people of our county. In 1963, Carteret Community College began as Carteret County Industrial Education Center, a division of Wayne Technical Institute. In 1968 the school was approved for independent status and the voters of the county approved a tax levy to build a physical plant on the Bogue Sound waterfront in Morehead City. The name was changed to Carteret Technical Institute, and over the years has grown both physically by adding more acreage and new buildings as well as in the curriculum, which now includes the arts, sciences, classes for students who enroll in a four-year college degree and dropouts from the high school programs to get their GED.

Carteret Community College, as it is known today, has made a great deal of difference in the lives of many of the young people of the community as well as senior citizens who enjoy taking courses and continuing their education.

BUILDING THE THIRD CENTURY AND BEYOND

BOOKS AND MORE!

An additional form of learning was offered to the citizens of Beaufort in the early twentieth century, and eventually to the entire county—the library. The first place chosen to have books available for people is believed to have begun in 1910–11 in the fourth courthouse that was located at the southwest corner of Courthouse Square. Mrs. C.L. Stevens, superintendent of Beaufort High School, organized the effort and students refurbished the room that was originally occupied by the clerk of court. After the building was torn down in 1915, the library disappeared for a spell.

The Beaufort Community Club, known today as the Beaufort Women's Club, organized in 1921 a library committee requesting the donation of books and funds to purchase them. In March 1922, a public library was opened once again in the Martin & King store on Front Street, most likely on the second floor. The library was open Tuesdays and Fridays from eleven in the morning until one o'clock and again from three to four. Thomas Martin was the librarian and the collection contained 120 volumes. There was a membership fee of one dollar per year and committee members went door-to-door to solicit throughout Beaufort.

It is presumed that the Martin & King store was in the 400 block of Front Street on the north side. The Kings and Martins were related through marriage. Dr. Francis Lathrop King and his wife, Sara Ward King, lived in a large house on Front Street in this same area. Unfortunately, the house was burned during the Civil War, but the brick building where he had his office and drugstore was not harmed. Dr. King and his wife had ten children, the first being Sara J., born in 1832 and died in 1889. Sara married Dr. Lafayette Washington Martin in 1853. He died in 1880. It was most likely their son, Thomas S. Martin—who served as a lieutenant in the navy during the Spanish-American War, wrote poetry and loved books—who was the librarian for the six months in 1922. A photo of what might have been the store that the library used during this time period has a door to the side leading to the second story.

By October 1922 it became necessary to find a new location. At a Beaufort Community Club meeting, Mrs. Sallie Shelton offered her home on Turner Street, but eventually the library moved to the home of the chairman of the Library Committee, Mrs. John Forlaw. John Forlaw and his wife, Lucy, were living with their daughter in a house on Front Street located between the Carteret Academy and Thomas Duncan's house. Their daughter was a schoolteacher and Mrs. Forlaw kept house for the family. Their home is no longer standing, replaced by a two-story brick building housing a restaurant and gift shop, with apartments above.

Another move came about in 1924, when the library and a public restroom were opened in a building owned by Charles A. Clawson at the corner of Craven and Front Streets, just around the corner from the Forlaw's house. It was on the second-floor hall where the Community Club met and the town commissioners eventually kicked in some funding each year to help the library and the rest room. The library took in over 550 volumes through donations of clubs, organizations and individuals, as well as "overdue" fines. Martha Carrow served as librarian and the town library was open one hour one day a week from September through May.

The library was on the move again. It went to the courthouse annex, the former graded school on Courthouse Square. Although it is unknown why the move was necessary, it is possible that the collection had grown and more space was needed. The books were kept in the former principal's office and later moved to a room on the first floor, as the library was still growing. Mrs. S.H. Haywood, president of the Women's Club, was the librarian and when she moved away, Annie B. Loftin took over. Fundraisers continued and eventually Annie was replaced by Vera Stubbs.

In 1934, according to former librarian Minnie S. Simpson, who served from 1960 to 1982, through the efforts of Miss Clyde Duncan, the Beaufort Library became a North Carolina Public Works Administration (WPA) Library Project. Carteret Post 99 of the American Legion offered the library the use of their clubhouse, a log cabin in the second block of Turner Street, which incidentally is almost in the same place where the present-day library building is located. The building had lights and water, but the WPA could only pay for salaries, so Miss Duncan, as the librarian, became the first to be salaried. Miss Duncan resigned a year later and Mrs. Stubbs returned.

By 1936 the WPA funds were directed more toward recreation projects and the library program was not renewed. Mrs. Stubbs was asked to supervise the activities, dances and socials in the "hut," and the library was allowed to continue. With all the activity it became necessary for the library to find another new home. During this period, the train depot now owned by the Town of Beaufort became available. The Beaufort Women's Club took on the job of refurbishing and under the leadership of Mrs. W.L. Woodard began raising funds to move the library, which occurred in December 1940. Sara Rumley was supervisor of library projects while Annie Gaskill and Thomas Respess were the librarians.

As funding was soon to end for salaries, Mr. Loftin, a former professional librarian, teacher and library supporter, approached the state. As a result, funding became available and the library became a county library with financial support from the state and the

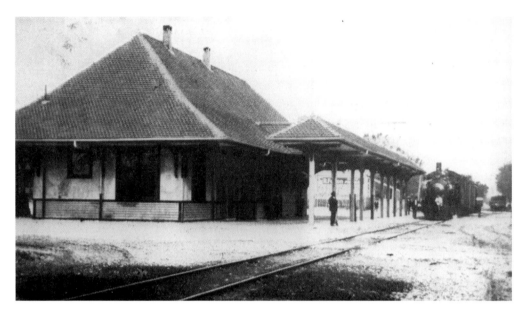

Beaufort train depot, circa 1920s. *Courtesy of the BHA and Laura Piner.*

county. In February 1943 the Beaufort Library was incorporated by the North Carolina secretary of state and became the Carteret County Public Library. Incorporators were Lena Duncan, Mrs. H.C. Jones and Mrs. W.L. Woodard. By 1949, along with the state funds, the county government began making appropriations to their new library. Although financial problems continued, it was the determination and dedication of many women in the community that kept the library open.

In the 1950s and 1960s the library board of trustees was under pressure to raise additional local funds to hire a trained librarian. An individual, in order to qualify, had to have earned a BS in library work of at least thirty hours in the library school studies. A trained librarian, however, was a condition necessary for federal and state funding. By 1956 the library board members considered joining a regional library association with Onslow or Craven County, or sharing a professional librarian part time from the counties. The board hired Miss Dorothy Avery, who worked five afternoons a week. During her tenure the branch was established in Newport and bookmobile service grew to thirty-five stations throughout the county. She resigned in 1959 and in 1960 Mrs. Simpson was hired.

In 1962 the library board reached an agreement regarding the joint regional library, and the Carteret County Board of Commissioners signed the contract merging the Carteret County Public Library and forming the Craven-Pamlico-Carteret Regional Library. But the train depot was still having problems with a leaking roof and electrical issues, and the Friends of the Carteret County Public Library, organized in 1961, began to plan and work toward constructing a building just for the library. Local businesses, individuals and federal and county funds made possible the new library building in the second block of Turner Street next to the location of the former American Legion "hut."

Groundbreaking took place in November 1970 and within a year the library books arrived. Over 28,000 in all came from the train depot into the new building. This library has room for a children's area, more open stacks, a magazine and new book reading area, plus an auditorium for meetings and programs, carpeted floors and air conditioning. In 1982, following Mrs. Simpson's retirement, Rosemary B. Garrish served for eleven years. Susan Simpson assumed the reins of the library when Rosemary retired.

The library celebrated "30 Years on Turner Street" in 2001. It has 45,000 books, computers with Internet access and an online catalogue. It also has one of the best and most complete research areas in the county. Microfilm readers and associated cabinets housing microfilm from the state archives to local newspapers, along with volumes donated by many families and writers, offer researchers a plethora of information. The library today has two branches and operates outreach services for the homebound and physically handicapped.

If you like to read, listen to music, watch movies or do research in a special quiet space, this is the place to find the right book, music or film video and learn about the history of the town of Beaufort.

MARINE STUDIES AND UNIVERSITIES

Piver's Island, a part of the marshland at the west end of the town purchased in the mid-1700s by Peter Piver, began "migrating" southward in the nineteenth century. The waters of the channel and the harbor moved the marshland, and with the help of early dredging of the channel, the island grew large enough to support a marine facility built by the federal government. Additional dredging and dumping of materials at the south end of the island made it possible to join a small shoal known as Round Rock with the island, creating space for a second marine facility built by Duke University.

NOAA/NMFS AND BEYOND

Douglas A. Wolfe, a former NOAA (National Oceanic and Atmospheric Administration) employee, wrote a history of the lab on Piver's Island. Titled *A History of the Federal Biological Laboratory at Beaufort, N.C. 1899–1999* and published by the Department of Commerce, NOAA, in 2000, Dr. Wolfe describes in detail the development of this laboratory and its significance to the area. In 1999, the lab known as NOAA's Center for Coastal Fisheries and Habitat Research celebrated one hundred years of existence in Beaufort and ninety-eight years on Piver's Island. It has the distinction of being the second-oldest U.S. Fish and Wildlife Service lab in the United States.

It was announced by the Commission of Fish and Fisheries in May 1899 that a new laboratory for marine biological research was to be maintained at Beaufort, North Carolina, with the probability of it becoming a permanent facility. A professor of biology, Dr. Henry Van Peters Wilson of the University of North Carolina, Chapel Hill, was granted $300 to rent a place in Beaufort and provide a working laboratory

Carteret County Public Library. *Courtesy of the author.*

and library. He chose what is known today as the Gibbs House on Front Street, built in circa 1850.

Access to Beaufort's waterfront was by boat at this time. The railroad only came into Morehead City; thus a steam launch from another station of the commission was sent to the new facility. Front Street had not been extended beyond Queen Street and Taylor's Creek ran nearly to the front door of the new laboratory/dormitory building. Between June 1 and September 15, a dozen men, faculty or students from a variety of universities, came to do research at this facility. In addition to working on individual projects, these men joined in an effort to learn about the plants and animals in the area.

Prior to establishing the new lab in Beaufort, the U.S. Commission of Fish and Fisheries was established by Congress in 1871. Spencer Fullerton Baird, a well-known and respected scientist, had been doing research in the summers at Woods Hole, Massachusetts, since 1863 and was extremely concerned about the decline in regional fisheries. As the first commissioner, he proceeded to establish the work of the commission in three areas.

In the 1880s, the old method of studying fisheries by lectures and text was detested by a Harvard professor, Louis Agassiz, who preferred hands-on research at a field laboratory. A colleague and former student, William Keith Brooks, established this same enthusiasm at Johns Hopkins, where he was a professor of biology and founded the university's Chesapeake Zoological Laboratory in 1878.

It was in 1880 that the trustees of Johns Hopkins voted to continue the laboratory concept, providing funds to keep the facility running. At this time a new site was decided upon, located four hundred miles south of Baltimore, with a vacant house large enough to provide housing and laboratory facilities for researchers. This was the Gibbs House

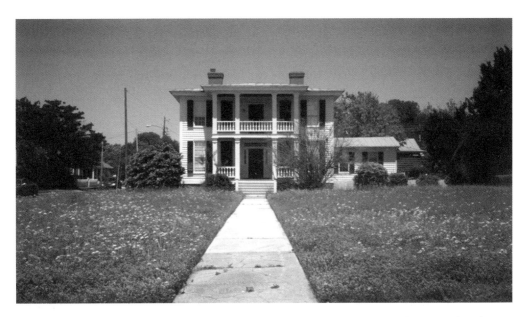

The Gibbs House, used by scientists from Johns Hopkins University, circa 1885–6. *Courtesy of the author.*

in Beaufort, which was rented and occupied from 1880 to 1885. In the first five seasons forty-plus scientists and students stayed at the laboratory in Beaufort.

In 1999, a friend, Lewis Bryan, graciously shared with me the Jane Addams Memorial Collection at the University of Illinois. This includes letters from George Bowman Haldeman, one of the graduate students studying at the Gibbs House in the 1885–86 years, written to his mother, Anna Haldeman Addams, and his stepsister, Jane Addams. His letters to his mother contain some of the more interesting insights into life in Beaufort at that time.

In August 1885 he wrote about his plans for leaving on the *Americus* for Baltimore in September, but the ship was high and dry on the strand as the result of a fearful storm that raged along the southern Atlantic Coast. He said it began about four o'clock in the afternoon and by ten o'clock the "fury of the wind and tide was something fearful." Shutters slammed with the "violence of demons" and filled one room on the first floor with pieces of glass. The tide came on "higher and higher, dashing across the small breakwater in front of the house," sending a deluge of spray into the yard and "silently gnawing" the shore. He continued that the rest of the household went out to experience the storm but he stayed behind.

Haldeman's letter of April 1886 stated that Dr. Brooks had written to Wilson about packing the things they would need for a two-month stay beginning in May. He told his mother that "the day is beautiful pale blue tints on the water and soft fluffy clouds," and not to expect any letters more than once a week as "the world moves slower here and events are proportionately less frequent." He also wrote about the insurance agent and revenue collector who visited the hotel, lighting it up and leaving it in gloom. Before closing he said that the cows "hover round us here as of old" with "hungry eyes and

contracted sides." When he used milk he said he realized what an effort it was for a Beaufort cow to give two or three quarts in a day!

A week later, he wrote again to his mother that they had changed their boarding place to the Seaside House, which was rented by the university, and that the proprietor, Mr. Lowenberg, sat and chatted with them during meals. He ended this letter with a request for funds. His May 11 letter said they were waiting for the schooner to take them to Nassau. Those to go on the trip included Dr. Brooks, Bruce Andrews and Dr. Mills, as well as several others from outside the university. He told her that the boarding place was improving wonderfully, as they were enjoying meals of lamb, green peas, new potatoes and radishes. Pony penning was to take place by the farmers who assembled to brand their wild horses, which supposedly descended from some of Sir Walter Raleigh's brought to this country.

Another week later George wrote that he would not go on the Nassau trip but rather stay in Beaufort and do research. Apparently the schooner was small and pretty well loaded so he and Wilson could do more by remaining behind. He told his mother that the boarding place was really good for this section of the country. He was enjoying dry toast, milk toast, rice and oatmeal and had given up cornbread. They also enjoyed baked fish and vegetables. Little in the way of recreation was to be had so he read a lot. A Lieutenant Winslow, who had attended the marine laboratory at Hampton, Virginia, was surveying the sounds and observing oyster cultures occasionally.

By the end of May 1886 George wrote that "a profound quiet is resting over our life at Beaufort." In June he wrote that life was simple and quiet and that the new boarding arrangement had passed through its first week most successfully and was far superior to any previous place. They were at home and free from intruders and too-obliging hosts. Breakfast was served at eight o'clock with oatmeal, coffee, eggs, milk toast or fried potatoes. A cold lunch at one o'clock included rice, bread and sometimes berries, with dinner at six o'clock of baked fish, chicken or some kind of meat, toast, etc., all for twenty-five dollars a month, with them furnishing the wood! Apparently it was a Sunday, and on a walk to the other end of town, near the cotton gin they passed one of the churches. The churchgoers greeted them cordially, but the "dull variations of ministerial choleric" caught his ear as they passed one of the "unpretentious little buildings" being used as a church. He stated that the "interior" was warmer than along the coast at the laboratory.

George's letter of June 26 said there were no vehicles of any interest here. Occasionally a dingy old buggy was seen but mostly it was carts pulled by a lame horse or an ox. He also reminded his mother that he had planned to get his degree in 1888 after five years at the university. About Beaufort, he said that the reputation for south winds was keeping up, as they had had one for a week. The first peaches and watermelons had arrived, and their "chef" secured the services of the best cow in the place, which gave two quarts of milk per day. The final letter was in August, saying he was anticipating a reply as to when he would be leaving Beaufort.

In 1886, Henry Van Peters Wilson was one of the graduate students at the Beaufort laboratory. He received his PhD from Johns Hopkins and remained for a year. He was employed for two years, from 1889 to 1891, as a "resident naturalist" at the U.S.

Fisheries Lab, Woods Hole, and in 1891 moved to the University of North Carolina. The following summers were spent in Beaufort doing research. Along with Joseph Austen Holmes, professor of geology and natural sciences, he presented to the Commission of Fish and Fisheries a case for establishment of a permanent laboratory in Beaufort where year-round observation of the life cycles and ecology of the south Atlantic coastal fauna could be conducted.

Operations were granted for use of the lab at the Gibbs House, but a concentrated effort continued for a more permanent site. A bill before Congress by North Carolina Senator Marion Butler was approved in 1900, authorizing the establishment of the facility and providing funds for construction and equipment. As the bill did not provide for purchase of land, Holmes garnered $400 from various universities and three acres were purchased on the north end of Piver's Island. A deed by a local Beaufort man, Alonzo Thomas, and eleven others transferred the property to the federal government.

Construction began in July 1901, and at the end of the fiscal year a two-story frame building that contained a laboratory, aquarium, office, a dozen bedrooms, two bathrooms and storage space was nearly completed. To the north was a one-and-a-half-story building housing a dining room, three bedrooms, a kitchen and bath. A powerhouse was located nearby. In addition, a boathouse, fuel shed and an eighty-foot landing pier were constructed. Open from late May to September 30 in 1903, thirteen researchers pursued their investigations. A new pumping plant was built and a sharpie and two skiffs were added to the number of vessels at the facility. The lab was mainly used during the summers until 1925.

During the First World War in 1917–19, the Beaufort and Woods Hole labs were handed over to the U.S. Navy, and all operations at Beaufort were closed. It was in the summer of 1919 that the Bureau of Fisheries regained possession of the lab. From 1921 to 1925 the U.S. Navy Bureau of Construction and Repair used the Beaufort laboratory. By 1927 the lab was designated as the center for the Division of Scientific Inquiry's investigations in the south Atlantic region. A boatman, clerk stenographer and scientific illustrator were added to the staff. In 1928, another boatman in charge of the new forty-six-foot two-cabin cruiser, the *Sandpiper*, was added.

In 1928–29 the main laboratory building was renovated and in 1929 the two-story residence for the director's use was built by Beaufort artisan Clarence Guthrie and his son, Claude. Another small powerboat was also added to the fleet. In October of 1929 a hurricane hit, with high water and strong winds breaking parts of the research tank walls that housed terrapins; 1,700 of them were released!

In 1931, Dr. Herbert F. Prytherch came from the Milford, Connecticut laboratory to be the new director at Beaufort. In his early tenure, research was primarily concerned with terrapin propagation, shrimp and oysters. Throughout his directorship, the lab remained open to visiting investigators in the summer as well as scientists from federal agencies. Dr. Prytherch's daughter recalls the wonderful days of growing up on Piver's Island.

Another hurricane in September 1933 severely damaged many of the lab structures. The next year a single-lane bridge was constructed connecting Piver's Island with the

Beaufort–Morehead City causeway that had been built in 1927. Prior to this bridge the access to and from the island was strictly by boat. The construction of the bridge peaked the interest of Dr. A.S. Pearse of Duke University and led to his promotion of the marine laboratory on the south end of the island. This bridge stood up to several hurricanes and was reconstructed over twenty years, and when the new draw over Gallant's Channel was opened in September 1958, the north end of the road was extended across the railroad tracks. The bridge was totally replaced in 1966.

In 1947 the second-oldest U.S. Fish and Wildlife Service laboratory was closed due to lack of funding from the federal government. Thanks to Dr. Prytherch and Representative Graham A. Barden of North Carolina, that shutdown lasted only three months. A change in departments of the U.S. government placed the laboratory under the Division of Commercial Fisheries instead of Fishery Biology. This change meant that "technological rather than biological" work would be done at the lab. Dr. Prytherch, who was offered a transfer to another program in Maine, declined and resigned as director.

The lab following Dr. Prytherch's retirement changed drastically in its focus. By November 1949 two scientists arrived to work on the new programs of radiobiology and shad. Additionally, the RV *Albatross III* was to perform oceanographic surveys off the coast for two months during the winter. These changes added new staff and revitalized the lab once again.

In winter 1953–54 a new brick one-story building was built adjacent to the existing lab at the south side, which was eventually torn down. The new building had office spaces, a library, a lab space and darkroom. In addition, the three original buildings, powerhouse, boathouse and carpentry shop were replaced by a single brick building. The powerhouse was taken off the island and placed on an empty lot on Pine Street between Hedrick and Live Oak Streets. A new name was given the lab once again: the U.S. Bureau of Commercial Fisheries, Biological Laboratory. In 1957 a new twelve-office wing was added on the south side of the new brick lab building. A new two-unit dorm was built in 1958 and converted ten years later into the automatic data processing facility. In another ten years it was expanded and finally converted to offices in 1987.

In 1970 the National Oceanic and Atmospheric Administration was established. The Bureau of Commercial Fisheries was renamed the National Marine Fisheries Service (NMFS) and transferred to NOAA. Due to this reorganization and establishment, the Beaufort laboratory became known at first as the Mid-Atlantic Coastal Fisheries Research Center, then the Atlantic Coastal Fisheries Center and finally the Atlantic Estuarine Fisheries Center. In 1997, the Beaufort laboratory was transferred from NMFS to NOS, the agency for coastal stewardship.

DUKE UNIVERSITY MARINE LABORATORY (DUML)

The following information is based on articles in the *DUML News* 5, no. 2, Fall 1987 titled "The First Quarter Century 1938–1963" by Dr. C.G. Bookhout, and the *DUML News* 6, no. 1, Spring 1988 titled "DUML Celebrates Half a Century," by John D. Costlow, former director.

In the early 1930s, the idea of having a marine laboratory affiliated with Duke University was thought to be impossible. Dr. Arthur Sperry Pearse, who at the time was chairman of the Zoology Department on the campus in Durham 180 miles from the coast, was approached by several colleagues about the possibility. Together with Dr. Thomas Powell Jr., Dr. Pearse visited several areas along the North Carolina coast before deciding on an island adjacent to Beaufort named Piver's Island, originally purchased in the mid-1750s by Peter Piver.

Maps of the area showed that Piver's Island and Round Rock Island were separate in 1911, but in 1912 had come together. Thus the extension of Piver's Island to the south was made. In 1935, the trustees of Duke University were convinced that having a laboratory where students could study marine life "up close and personal" in their own environment was a good idea. The university acquired the Hamlin property from Charles L. Skarren Jr. and in 1938 Charles Abernathy and his wife sold the property to the south, which was the former Round Rock Island, as well as the marsh section connecting it to Piver's Island through dredging of the Intracoastal Waterway and Gallant's Channel, to Duke University.

Over the next three years construction of three wooden dormitory buildings, a two-room building for classes and laboratory equipment, a small boathouse and adjacent dock was completed. In the summer of 1938 a total of sixteen students descended on the island, the first of many thousands who would call DUML home throughout the years. By 1941 a dining hall and resident investigator's building appeared on this coastal campus. As more and more students and visiting faculty began to use the facility, an additional laboratory building became necessary. Ten years after the first buildings were constructed a second laboratory was completed. It was not until 1950, however, that Dr. Pearse's concept began to bloom into a year-round teaching and research arm of Duke University.

The original idea was to provide a place for students to live and do research in the summer, as well as to provide access for visiting classes in the fall and spring. Dr. C.G. Bookhout, one of the first to teach at the lab beginning in 1939, was appointed director eleven years later. During the 1950s, enrollment for summer courses and the number of teaching and research persons grew rapidly. New courses were added to the original, resident staff arrived and the marine lab reached year-round status. Three new laboratory buildings were added to the complex in 1954, and with dredged material increasing the size of the property on the south end of the island, a seawall was constructed and a new dormitory was built in 1963.

An ever-growing desire on the part of students and faculty to understand more than just the near-shore marine life led to a proposal to the National Science Foundation for the establishment of a cooperative program in research and training in biological oceanography. Included, and necessary for such a program, was the request for a research vessel large enough and well equipped to explore and study the areas of the Atlantic Ocean from Virginia to Florida. With the approval of the proposed program in 1961, including the research vessel, construction was begun on the RV *Eastward*, Duke University's first oceangoing laboratory. In conjunction with the ship, a new oceanographic laboratory was also built on the marine laboratory complex.

All of this activity took place under the guiding hand of Dr. Bookhout, known fondly to many as "Bookie" during the early 1960s. When he stepped down as director in 1963, the original idea of a summer place at the coast for research of marine life had grown into a full-fledged interdepartmental and interuniversity teaching and research facility for marine sciences, as well as a nationally recognized program. After a year's absence, Bookie returned to the helm of the continuously growing marine facility on Piver's Island. Plans were formulated to expand the resident teaching staff as well as the physical structures to provide for additional researchers, including graduate students, visiting faculty and expansion of course offerings.

In 1968 the directorship changed hands, and Dr. John D. Costlow was endowed with the awesome task of making those plans come to fruition. During his early years and the 1970s, a new, modern, three-story lab building was erected along with a library/auditorium complex. With the growth of programs and facilities came the responsibility of maintaining the complex without the need for the parental oversight from the Durham campus. A maintenance facility with storage space and a residence was built on the island.

To provide additional housing for visiting scientists, an apartment complex across the channel in Beaufort was provided as a gift from the Cocos Foundation. Located on Front Street in the first block, the apartments were originally three separate houses, one built in the 1700s and the other two in the mid-1800s, and were known as the Davis House boardinghouse, operated by Elizabeth Davis. Along with this apartment complex was a small house on the water side that had at one time been a bathhouse, or perhaps a boathouse, adjacent to a gazebo. Visitors to the area in the late 1800s spent much of their summers at the Davis House.

After twenty years of plying the waters off the East Coast, the RV *Eastward* was in need of some tender loving care and refitting with more modern equipment. The new director of the oceanographic program, Dr. Richard Barber, took the initiative and in 1980 formed a Duke/UNC oceanographic consortium. Following competition among several marine facilities, the consortium was granted the contract to build a new research vessel, to be named the *Cape Hatteras*. The vessel is in operation to this day, and when in port can be seen docked at the east side of the marine laboratory complex.

As the resident staff grew, so did the variety of academic departments and classes, ranging from marine geology to the environment. A Natural History Resource Center was built and housed in the library/auditorium facility. The Duke Marine Biomedical Center was established in the late 1970s, with the main focus on marine and freshwater environmental research and the effects of toxicants on the health of marine and human life. During the decade of the 1980s, the programs of the marine lab expanded to include scientists and institutions from around the globe. With assistance from UNESCO and the Rockefeller Foundation, the International Training Program in the Marine Sciences was instituted. Over one hundred scientists from twenty-six countries participated over a five-year time span.

Pre- and postdoctoral persons from many countries in the Middle East, as well as the Far East and the Soviet Union, mingled on the DUML campus with undergraduates

R/V *Cape Hatteras* at the Duke marine laboratory dock. *Courtesy of the author.*

and graduate students from across the United States. The exchange of cultures as well as sciences was incredible to behold. Many scientists from around the world came to teach, do research, enjoy a sabbatical, give seminars and serve as consultants to young scientists.

The marine lab, working with several other organizations and the town of Beaufort, was instrumental in establishing the Rachel Carson Estuarine Sanctuary. Rachel Carson, a renowned environmental and marine researcher, came to Beaufort in 1938 and worked at the Fish & Wildlife Laboratory at the north end of the island. She was on a ten-day vacation with her mother and two nieces, spending time on the beaches of Bird Shoal, Carrot Island and Shackelford Banks watching the birds and marine life. In 1941 she wrote a chapter about shorebirds. She spent time at the library and museum at the Fish & Wildlife Laboratory, which was her primary reason for coming to Beaufort. In 1950 she wrote her famous book, *The Sea Around Us.*

Following the change in directors in the 1980s, in early 1990 the marine lab shifted its focus more toward the environmental aspects of research and study. Three directors have followed Drs. Bookhout and Costlow and have maintained the presence of Duke University and DUML across the "cut" from Beaufort.

OCEAN, FOOD AND FUN

WHALING DURING THE EARLY DAYS

One of the earliest industries on the coast of North Carolina was shore whaling. Although different tactics were used from those of New England whalers, it was just as exciting and dangerous.

Located near Cape Lookout, whales were spotted as they traveled north in the spring. Apparently, the earliest use of the cape was in the mid-1720s when whalers from New

England stopped by. According to Governor Dobbs in 1755, the fishermen from up north had a considerable business from Christmas to April as whales went north.

The Shackelford Banks residents designed their own whaling boats, pointed at both ends for launching and beaching. Not all the folks were whalers, which was a short-term industry. Right whales, humpbacks and finbacks were the most sighted. Swimming north, they would round the bight of the cape as close as eight miles from shore. All the whaling was by hand, with the exception of the whaling gun used to spear the prey.

In January, early in the morning on the high dunes of Shackelford Banks, the watchmen stood and at the sight of a whale the cry would go out. The younger men would scamper for their boats and push off into the ocean. Eight men rowed the boat while the gunner stood in the bow at the ready. As the whale would "blow" the gun would go, aiming for that special spot. At the whale's death, the men tied it to lines and towed it to shore to be beached at high tide. This way the whale would be stranded on the beach when the tide went out and this made it easier to cut away the blubber for the oil.

Onshore the women and children kept fires going with huge pots of water as well as coffee and hot food for the men. The blubber from the whale, cut off in huge chunks, would be carefully placed in the boiling water. A trough would carry the hot water and the oil to hogshead barrels. The oil was strained through beach grass. About forty barrels of oil would be gathered on a good day. The other parts of the whale were used as well: the bones were used for stays for women's corsets and the teeth for carvings or combs.

Off to market, the barrels of oil were taken by boat to Beaufort, where schooners would take them to Baltimore. After the turn of the century, into the 1900s, whale oil was no longer needed, as electricity had been discovered and brought to town. This was the end of whaling in the South.

FISHING FUN

If you live at the coast, no matter if it's New England, the mid-Atlantic, the Southern shores or elsewhere, fishing is a natural happening. In early days, fishing, scalloping, clamming, crabbing, oystering and shrimping provided food for one's family. An overabundance of your catch might be shared with friends and neighbors. Later it was realized that money could be made by selling your catch to a local store, restaurant or dealer.

Today the commercial fishing industry that provided Beaufort families with a good living is nearly gone. With the increase in foreign fish companies selling their products in the United States as well as the fish populations being depleted, it is difficult for local companies to continue operations. Families no longer pass the business along to the next generation. The children no longer stay home to do a job their fathers, grandfathers or even great-grandfathers did. Times have surely changed.

Instead, locals and out-of-towners with small boats spend a day on the waters nearby catching whatever is running. Some local folks still clam along the rivers in their backyards, and fishing tournaments bring in the larger oceangoing fishing boats with

Commercial fishing boats at dock on Gallant's Channel, taken from the Beaufort Inn. *Courtesy of the author.*

their crews to take a chance at the "big one." Piers and ocean shorelines also provide excellent places for a day of fishing; however, piers are slowly being torn down and making room for condominiums along the Bogue Banks.

BREVOORTIA TYRANNUS, BETTER KNOWN AS MENHADEN

Menhaden fishing, once one of the most commercial of fisheries, is now all but gone, with only two plants left north of North Carolina. At one time, during the war years of 1942–43, eight of the thirty-two menhaden plants were located here in Carteret County, with Beaufort Fisheries the most well known in our town. An article in *National Geographic* in 1949 titled "Menhaden—Uncle Sam's Top Commercial Fish" gives some insight into this industry and the fish called menhaden, as does an article in the *Carteret County News-Times* of 1943 with the headline "Virginia, Florida Boats Meet Here for Menhaden Fishing."

Known up and down the East Coast and the Gulf, *Brevoortia tyrannus*, or menhaden, is a member of the herring family. Some places call it bughead, bugfish, oldwife, alewife, greentail or chehog. In North Carolina they are sometimes called fatback, shad or pogy. Indians along the New England coast knew the menhaden before the colonists arrived. A Narragansett word meaning "that which enriches the earth" is the most common translation, for the Indians would place one of the fish in each hill of corn to promote crops.

Plants that process the menhaden have been established in Maryland, Virginia, Delaware, Connecticut and North Carolina. The first fish oil "factory" was on the Rhode Island coast in 1811, using the "rotting" process to retrieve the oil. Times have changed though, and in 1948 thirty-one menhaden reducing plants were in operation along the Atlantic and Gulf Coasts. New England sites were abandoned because of cold water shortening the fishing season. The plant farthest north was on Long Island.

The biggest catches of menhaden are made in the fall of the year. Menhaden like the shallow waters of the seacoast, as well as brackish bays and sounds. Many of the fishermen follow the menhaden as they move along the shore. Menhaden boats in the past were wooden and built especially for this use. The bow is usually very high to withstand the rough waters of the ocean and allow a wider view of the water, while the aft is very low—only a few feet above the water. Boats are generally 85 to 150 feet long. Included in the center are holding places for the catch. There is usually a galley with the crew and officers' mess as well as the pilot house and officers' quarters. Steam or diesel engines are the propelling power. Since the Second World War, some ships have been converted to menhaden boats.

The actual fishing is done with the purse boats and the seines. These boats, lashed together, aim for the near side of a school of fish. On reaching them, they separate, swinging in a large circle, and at the same time pay out the seine. The top of the net is kept afloat by scores of corks and the bottom weighted down by leads. When the purse boats meet the striker boat on the other side of the school, the seine ends are secured and the bottom drawn together, or pursed. Menhaden fishing, like hand-line fishing, is a gamble.

After loading up with the catch, the ships go to the reducing plants. At the Beaufort Fisheries plant, ships were secured and the long chute, about four feet square, was swung into the hold. The chute contained an endless belt with scoops attached, into which the men in the hold of the ship would shovel the catch. The fish would then go to a deep trough thirty feet above the hold and down into a drum that would deposit the fish on another belt to be carried into the plant. If the plant is not operating at the time, the fish are deposited in a raw box for brief storage.

The process includes getting the fish to the cooker, a long stationary cylinder where they are continuously in contact with live steam. It is here that the oil of the cells of the fish is broken down. A conveyor moves the totally mangled fish to the presses, where oil and water that is squeezed out flow into separating tanks. Fish parts and water are removed and the oil is funneled into storage tanks. The scrap, residue in cake form or dried, is used in the commercial fertilizer and cat food industry.

In the 1980s nine menhaden reduction plants were closed permanently along the Atlantic Coast. At the same time two new operations began. In 1990 five reduction plants with thirty-seven vessels processed Atlantic menhaden for fish meal and oil. Land-based plants are currently located at Reedville, Virginia, and here in Beaufort, although the Beaufort plant is on the verge of closing.

In the November 1943 article in the *News-Times*, Harvey Smith of the J. Howard Smith plant at Gallant's Point said, "The fish are here if we can get out to get them." High wind, rain and cold weather kept most of the boats in port. Mr. Smith's twelve boats were coming in from Reedville, Virginia, while five boats from Fernandina, Florida, were to fish for the Queen Fisheries. Nine boats were to fish for the Wallace Fisheries of Morehead City. The R.W. Taylor Co. was also planning to send boats out, some of which were to come from Reedville, Virginia. The Carteret Fish & Oil Company of Morehead City would not operate, while Beaufort Fisheries of Beaufort would as they do year round.

In an interview with Art Latham of Raleigh, Jule Wheatly—current president of Beaufort Fisheries Inc.—stated that when he was a boy, the town had eight fish factories. Menhaden was king and it kept Morehead City and Beaufort going. Nobody complained about the smell, that of fish being rendered to oil and ground to meal, for that was "the smell of money," particularly for the people who lived here. If there was no smell, people got nervous, because it meant nothing was being processed.

Developed in the 1890s, the industry found an abundance of fish in the Chesapeake Bay and off the North Carolina coast. During the 1940s the menhaden was used primarily for high-protein animal feeds and oil production. The oil was used to make soap, linoleum, waterproof fabrics and paints, while the fish meal was mixed with feed. The peak of the industry was between 1953 and 1962. Beaufort Fisheries was founded in 1934 when Mr. Wheatly's grandfather assumed the note on a Standard Products Co. processing plant. As Jule says, they have only closed down once since the plant was established, and that was due to low prices in the 1980s. In 2002, the plant was closed briefly for major repairs.

The factory, located on Taylor's Creek, and two ships employ eighty people, and in 2002 it was the county's ninth-largest industrial employer. The ships—the 170-foot, 600-ton *Coastal Mariner* and the 176-foot former oil tanker *Gregory Poole*, weighing more than 600 tons—cruise at seventeen-plus miles per hour, each with a sixteen-man crew and possibly one or two spotter planes. Once back at the factory, the process of unloading begins. Beaufort Fisheries produces 7,500 tons of meal and from 300 to 400,000 gallons of oil a year.

In a conversation with Jule in May this year, he said there used to be five plants in Beaufort, one on Phillips Island and two in Morehead City. The boats would come to the plants from October to the end of January, thirty men per boat and one hundred boats total. It was back when Front Street had grocery stores, hardware stores and fish houses along the waterfront, before urban renewal, that the menhaden workers shopped here, bought groceries here, went to the drugstores and doctors here, ate in the restaurants here and boosted the economy of the town for at least four months of the year. Even though the local people did the same year round, it was that extra boost that kept everyone going from year to year.

When I first came back to Beaufort to stay, in 1974, I was told one evening while sitting on the steps of St. Paul's Episcopal Church waiting with others to get in for choir practice that what I was smelling in the air was "money." And even a few years ago, when I would walk along Front Street in the early morning, I would stop dead still to watch the *Gregory Poole* or one of the other boats from somewhere else plying the waters of the harbor and Taylor's Creek, going to the factory. For a long time, the sailboats and small yachts that would anchor in the harbor from October through January knew they had to stay closer to the Bird Shoal/Town Marsh island or else they might be bumped by one of those big seagoing menhaden boats as it came down the cut.

It truly is a sad thing to lose such a longtime industry that helped support the town of Beaufort from the 1930s until today, but change is happening. As Jule said, in his lifetime Beaufort has gone from being a small, quaint fishing village to a tourist town, with over one hundred plaqued homes in the National Register Historic District, bed-and-

Menhaden boats at the docks on Front Street. *By Diane Hardy.*

breakfasts galore and the waterfront with fancy shops and eateries to serve these visitors. And today, condos are sprouting up along every inch of water imaginable, preparing for the onslaught of the "baby boomers" who will soon be retiring.

GETTING HERE FROM THERE

BOATS, BRIDGES AND FERRIES

Boats have been a necessity for citizens of Carteret County and Beaufort for centuries. When Beaufort was first settled, the only way in and out was by boat. Surrounded by water, it was not until the mid-1700s that the vestry and town officers of the county designated people from populated areas to build bridges to cross over the many streams located in the area.

THE CANALS OF CARTERET

In the late 1700s, the old canal was begun by running north through Harlowe's Creek and connecting with the southbound Clubfoot Creek, connecting the Newport River and Beaufort's port with the Neuse River and the inland town of New Bern. Work on the canal was sporadic at best, and with the waters of the Clubfoot Creek higher than those of Harlowe's Creek, it was thought to be expedient to build a lock, which never came about. Although used by some smaller vessels, the canal was deemed not to be useful as a commercial adventure. The canal ended its attempts at being a viable business in 1834. The history of this canal is similar to that of the Erie Canal in New York State, although without the same outcome.

Nearly one hundred years passed before the new Core Creek Canal was dredged and opened. The Big Ditch, as it was called, was dug between 1907 and 1910. The U.S. Army Corps of Engineers began the job of dredging the waterway from the Neuse River, south through Adam's Creek, then through the forest lands into the Core Creek and finally to the Newport River. The shoreline was straightened and strengthened, and the job was completed in mid-November 1910, with a celebration in January 1911. Several dredge boats were used, providing work for many local folks.

The celebration parade included government vessels and dignitaries, including Judge C. Abernathy of Beaufort and several members of Congress from Pennsylvania, Florida, Minnesota, Louisiana and North Carolina, all members in some way of rivers, harbors and waterways associations. Today this Core Creek Canal is known to boaters worldwide as part of the Intracoastal Waterway connecting Maine to Florida.

Spanning the Waterways

Bridges have made travel much easier for locals and visitors alike. In the early days, small, narrow wooden bridges would give horseback riders the opportunity to visit folks on the other side of the creek, or wagons and carts could haul products to the port in Beaufort for shipping to far-off places or travel northward to New Bern. As the years went on, the bridges grew longer and wider, more sturdy and today are even higher.

Along the Core Creek Canal the first steel bridge was built in 1910 on the shore and hand operated. By 1935 a second steel bridge was built, which was a swing bridge, turning on an axis. Several years ago, the Core Creek community was to see a high-rise bridge above the land that Henry Stanton of Rhode Island had settled in the early 1700s and nearly over the Methodist church built in 1939 by Colonel Fairleigh Dickinson, a seventh-generation descendant of John Dickinson, a physician who had joined Stanton in the small community. It is hard to imagine how the early settlers of the Core Creek area would feel today about such a high and long bridge.

Another high-rise bridge now connects Morehead City with the causeway to Beaufort. A causeway, according to the New World Dictionary, is first a raised path or road, as across wet ground, or second a paved way, road or highway; ours is more like the second. The first causeways were actually built in the town of Beaufort in the 1800s by various gentlemen so people could get from one side of the street to the other. But this causeway was laid out over the marshland between Morehead City and Beaufort along the Newport River. Dredges were brought in to pull material from the bottom of the river and dump it in the necessary spots.

In Beaufort, the bridges from the causeway over Gallant's Channel were draws, meaning each side of the steel bridge would raise up to allow ships and pleasure boats to pass under the open space above. The first road bridge was built in 1927. There weren't many cars in the area, according to Louise Nelson, who was born in Beaufort in 1911 and enjoyed her early days here. But a neighbor of her family's had a car, and as many folks as possible were loaded in, and off they went across the new drawbridge on Ann Street, across the channel, down the causeway and across the other new drawbridge into Morehead. What a trip.

In 1954 the second drawbridge was built connecting the new causeway road with Beaufort on Cedar Street, just north of the railroad trestle and draw. Today this drawbridge is known as the Grayden Paul Bridge in honor of one of Beaufort's more famous people. Thus the three primary streets running more or less east and west were each used as access in one way or another to Beaufort and other parts of the county. Ann Street was the entryway for the first automobile bridge; the railroad trestle came into Beaufort on Broad Street; and the third Highway 70 bridge enters on Cedar Street.

LET'S GO BY FERRY

As with other modes of travel in the early times here in Beaufort and the surrounding county, small boats were the primary way to get around. Someone who may have had a bigger boat, and knew his friends and neighbors needed to get across the river, would offer to take them, for a price. Well, that was the beginning of the ferry business.

In the 1960s the Taylor brothers began a ferryboat company, taking people from Atlantic near the eastern end of the county to Ocracoke, a spot on the Outer Banks. A year later the operation was under the management of the North Carolina State Highway Commission. One roundtrip a day connected the Outer Banks with the mainland. In 1964 the state built a terminal at Cedar Island, which made the distance shorter, plus the ferry channels were better. This allowed two roundtrips a day to Ocracoke.

By 1965 the ferry system consisted of three ferries making the two-hour-and-fifteen-minute one-way trips from Cedar Island to Ocracoke. The distance, as the crow flies, is only twenty-two miles, but what better way to travel than to get on a ferry from Cedar Island to Ocracoke, let the captain do the steering, let the state pay for the gas that makes the ferry run and sit back and watch seagulls, porpoises and the waves of the Pamlico Sound. Silence is golden, I have heard, and when traveling on one of these ferries over that twenty-two-mile stretch it certainly is. Sit in the upper cabin, stand along the side or stay in the car. No matter how you go it's a trip you can't forget.

The state also has ferries that operate between Cherry Branch and Minnesott and take passengers to some of the lovely places in the Inner Banks of North Carolina, such as Oriental, a sailors' haven. You can even take a couple of ferries from Carteret County across the Neuse River and the Pamlico River and arrive near Bath and "little" Washington.

Here in Beaufort and at Harker's Island, there are smaller ferries that will take you without your vehicle to see Shackelford Banks, Bird Shoal, Town Marsh or the cape at the southern end of Core Banks. These smaller ferries leave from docks on Front Street in Beaufort or from the nearby National Park Service dock at Harker's Island. There is nothing like spending a day on one of the pristine islands off the shoreline of Beaufort. With no traffic, streets or buildings to obstruct your view, or venders begging you to eat, you can enjoy the day in solitude and peace, swimming, finding all sorts of shells that have come from around the world and landed on our shores, watching the ponies as they wander the islands, eating and playing and sometimes being rambunctious as well. Be sure to carry your suntan lotion with you and have a great time. You'll be home in your own bed in the evening.

VISIT OUR CAPE

And of course, you must see our famous Cape Lookout lighthouse while you are at the island beaches. On old maps this cape was called "promontorium tremendum," or horrible headlands. Today we call it Cape Lookout, or just "the cape." I'm sure people from Cape Cod feel the same way, as they tend to call theirs the cape as well! The name Lookout may be from the fact that the early whalers used to go to the highest dunes to look out for the whales as they swam northward.

The first lighthouse in this area was authorized by Congress in 1804 and went into service in 1812. It was 96 feet high and stood as a beacon to ships offshore for forty-some years until the present-day lighthouse was built in 1859. The new lighthouse is 160 feet tall with a fixed white light, whereas the first lighthouse used candles or whale oil lanterns.

Lighthouse keepers were important so the whale oil could be replenished as needed and the light would be burning constantly. The first keeper was James Fulford, who served from 1812 to 1828. William Fulford took over then and stayed as the keeper until John Royal began his service in 1854. All of these lighthouse keepers lived at the lighthouse with their families.

With the need for a newer, bigger, stronger lighthouse, in 1859 our Cape Lookout lighthouse was built. Keepers were now able to work in shifts and live in town instead of at the lighthouse. Mr. Royal, his son and others shared the duties to keep the 160,000-candlepower light glowing.

During the War Between the States, the first lighthouse was destroyed in 1861 when a raid of Southern sympathizers actually tried to blow up both lighthouses to prevent the Yankee navy from entering the inlets and coming into the Beaufort Harbor. Unfortunately, or fortunately depending on how one sees this raid, only the first lighthouse went down. Cape Lookout lighthouse received some minor scrapes and bruises but has survived.

Cape Lookout is part of what are known as the barrier islands, a chain of islands mostly under the sea. At the end, or the beginning, they merely slip into the ocean rather than dropping steeply. Barrier islands are, as quoted in the new issue of *The Cape Lookout National Seashore Newspaper*, non-living geological formations of the earth. They move themselves to survive storm waves and although they are not really alive, they seem to have an innate sense of survival. They anchor themselves to withstand wind, migrate to shallow waters to keep from drowning and grow or shrink to fit their surrounding environment. As the islands change, so do their "shoals" under water. It is the lighthouse located at the cape that lets sailors know of the danger of the shoals.

The 1859 lighthouse was painted in its familiar diamond pattern in 1873 and was automated in 1950. It is 9 feet thick at the base, 1 foot 7 inches near the top, stands 150 feet above mean water and has 207 steps to the gallery that surrounds the top. The light is produced by two rotating beacons and can be seen for twenty miles with a flash every fifteen seconds. If you are staying at a place along the beach of Bogue Sound, you might catch the lighthouse wink at you!

Cape Lookout is at the southern end of the Outer Banks of North Carolina. It is near here that the waters of the Gulf Stream travel north and the Labrador Current meets it

Notecard by author of Cape Lookout Lighthouse. *Courtesy of the author.*

coming south. Throughout warm summer months locals and visitors alike spend hours in the sun and surf of this cape and in the cooler winter months they keep busy by fishing.

AND WHAT ABOUT A TRAIN

If you have ever been lucky enough to travel on a train you know the feeling you get as the wheels clickety-clack on the rails, especially at night on a sleeper car in the upper bunk. The best night's sleep ever! Or take a train from the big city to a smaller one several miles away, with the windows open, soot everywhere, farms passing with cows, horses, sheep and goats going by. Oh, well, that's another time and place!

In Carteret County the train made its first appearance in Morehead City in 1856. It was not until fifty years later that Beaufort had its first train visit. The tracks were laid on a causeway over the Newport River marshes with drawbridge trestles at each end to connect the towns of Morehead and Beaufort. A freight station was built on the piece of land where there had been a lumber mill, at the western end of Broad Street. The tracks continued down Broad Street to the new passenger depot at the corner of Pollock and Broad Streets. It was here that visitors to the "shore" alighted and were met by porters with carts from the Inlet Inn to take luggage and passengers to their summer home.

With the train arriving in Beaufort, people could come from all over the state and elsewhere to spend a beautiful summer or holiday in the peaceful, restful, quaint, historic town of Beaufort. Thus was the beginning of tourism! Businesses were now able to send their goods on the train to some of those far-distant places. The lumber company at the east end of town even had tracks laid that connected to the main road, as did the fish scrap and oil factory that was at Gallant's Point.

The only vestige of the train tracks today can be found near the Turner Street and West Beaufort Road intersection. The tracks running along Broad Street were taken up

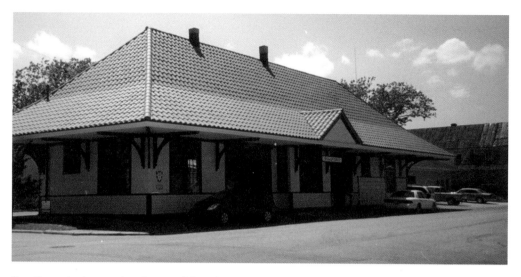

Beaufort train depot today. *Courtesy of the author.*

in 1999, seven years after the last train made a run through Beaufort. It was a sad day for those of us who lived along or near Broad Street. It was quite a sight to see the big engine, clattering on the rails, shaking the ground, with her whistle blowing at every cross street. But big trucks had replaced the need for trains to haul items out of Beaufort.

The original freight station was carefully taken down with the hope that it could be reassembled near the area of the town property so that it could be used for a community building. Unfortunately, that did not happen, for the rot in the old building was found to be much more than was originally thought and only parts of the building's timbers could be saved. The building adjacent to the freight station, the Beaufort Ice & Coal Company, was also done away with. Today, local entrepreneurs have developed the property into a site of several three-story, single-family homes known as Gallant's Landing.

The original passenger station has been loved and cared for over the years by several different groups in town, including the town itself. At different points in time it housed the public library and was a center for mentally handicapped persons, and the Beaufort Women's Club currently uses the building on the east end, while the town uses the west end for all the various commission meetings that are held throughout the month.

Following the recent restoration of the building, John and Virginia Costlow developed the history of the train and its service to the town and community in photos and items that have survived over the years and have been donated to the museum. It is an incredible journey back in time to look at what they have accomplished. In addition, John has been instrumental with many other friends here and there in getting train buffs together during the first weekend in December to share their miles of rails and different size model trains for anyone who might be interested. This is a weekend you don't want to miss if you love a train!

FLYING AROUND

THE EARLY DAYS OF FLIGHT IN BEAUFORT

According to a series of articles by Ruth Barbour in the 1980s titled "Carteret's 50 Years in Aviation," the first airstrip in the county was an open field in the area of Highland Park in Beaufort in 1930. The first plane was owned by a contractor from Rutherfordton who was here to pave streets and roads. His pilot began giving lessons to young men in Beaufort. Julius F. Duncan Jr. became a co-owner of the plane, which crashed twice, once in 1930 and again in 1931 with Mr. Duncan at the controls.

It was, however, Earl Taylor of Beaufort who kept the idea of flying going here. He had taken lessons in the 1930s in Goldsboro and Rocky Mount. In late 1939 and early 1940, Earl Taylor flew a plane owned by a gentleman from Washington, North Carolina, who was in the oil business on the causeway. The county took over the West Beaufort subdivision for nonpayment of taxes and the wide open area was perfect for an airfield. The developers from elsewhere and locally had laid off building lots in the 1920s. In 1937 Mr. Taylor put a 1,400-foot airstrip on the property he owned next to the subdivision. Three years later he lengthened the strip to 2,900 feet.

The county commissioners approved the use for the county land. Mr. Taylor, who farmed and ran a sawmill, cleared a north-south strip as well as an east-west. A bill in 1941 passed in the North Carolina Legislature gave the county authority to maintain airport facilities in the county. With World War II, the commander of the Civil Air Patrol (CAP) in Charlotte contacted Mr. Taylor about using the airfield for planes to patrol the coast for submarines. Mr. Taylor agreed, but the CAP would not allow civilian planes at the facility.

DURING THE SECOND WORLD WAR

The Coast Air Patrol was formed along the East Coast during the early days of World War II. All civilian pilots, they risked their lives with little pay to fly over the Atlantic, spotting German subs that were sinking American ships. In late summer 1942, the activity of the submarines off the coast of North Carolina between Cape Hatteras and Cape Fear had increased at an alarming rate. Through the efforts of Frank E. Davison, state wing commander of CAP in North Carolina, authorization to establish a base at Beaufort was given on September 2, 1942.

There was no airfield as we know today, only a swampy, grass-covered area, under water at high tide, with a house in the middle of it. CAP persons coming in to fly from this place asked local folks for directions to the "airport" and most didn't know there was one! The men worked hard to clear the area, mowing two runways on the higher ground, and by the end of September patrols went out daily, weather permitting. The men busied themselves when not flying by continuing to clean up the land and existing buildings from which to operate, making it a real base.

The government made a deal with the county during the stay of CAP Base 21 and built the airport with asphalt runways. In 1943 the county received the authority to lease the West Beaufort area with its airstrips to the navy and to acquire additional land. Houses and the sawmill had to be removed. Thirty-seven acres were raised to seven feet above sea level by dredging and dumping on the property.

In January, CAP Base 21 at Beaufort began building runways with help from the army trucks, Earl Taylor's tractor and some of the county convicts. The facility was inundated by water and mud, so the pilots had to use the marine auxiliary field at Bogue while construction continued. The north-south runway was completed by January 10 and the pilots returned to Beaufort.

In February, for the first time in months, a submarine was reported sighted near Beaufort Inlet. A day or so later the sheriff reported that German saboteurs had landed in the Bogue Inlet area. March brought news that the CAP had been taken over by the army air force. Patrols continued. Smoke on Harker's Island was reported, which turned out to be a brush fire north of Marshallberg. In April, an amazing event occurred. A black man digging for clams at Gallant's Point found a wooden board with telegraph keys on it in the marsh. Quickly identifying the inscription as German, headquarters was notified and within days the navy began sharing intelligence on enemy action and shipping activity.

Throughout May, submarines were sighted and merchant vessels and tankers were being torpedoed and sunk. On May 18, an explosion shook the entire area. A depth charge in a boat moored at the port terminal in Morehead City had detonated, sinking the boat and killing seven men. Near the end of the month, a navy pilot in a Corsair with the motor missing was told about the little field on the other side of Beaufort where he could land, which he did with no damage to the plane.

June saw unplanned landings of several flights, a day of cold and blustery weather when a Cherry Point plane had to land and a navy plane that tried to take off and narrowly missed rooftops in Beaufort town. On June 27 two of the best pilots were killed when they took off from the field, rose two hundred feet and nose-dived to earth. The field was taking shape, trees were down, mud was smoothed and the new hangar was completed. Then the rain set in.

CAP Base 21 was just getting set up once again when the news came that all coastal patrol bases would be closed. By the end of July the word was that the Beaufort base was to merge with the Manteo base and everyone would be sent somewhere in the United States. Still the work went on, the planes were moved to the new taxi strip and old runways were covered with water and sand in preparation for a new field. Governor Broughton came to visit in August. Lumber arrived for crates to be made for shipping the equipment and furnishings. August 31 saw the departure of all but mechanics and four pilots. On December 20, 1943, the men and women under their same commander were transferred to a base in Virginia. A few months later the base was relieved of its assignment and disbanded.

In 1946 the marine corps turned the property back to the county, and the county leased the airport to Mr. Taylor, who started a flight school there with Bob Burrows as

a partner and instructor. At one point Mr. Taylor had five instructors and twenty-one planes, and he obtained his pilot's license with training from Mr. Burrows. A service offered by Mr. Taylor was fish spotting for the menhaden factories.

In the summer of 1946, Southeast Airlines began flying in and out of the Beaufort airport, which only lasted one year. In 1947 Piedmont Airlines was to begin flights for summer tourist season and fall fishing, but that was delayed a year. The next year the airline provided two flights from May to October and then from 1950 to 1962 that was decreased to one. Service ended due to lack of passengers. In 1973 Wheeler Airlines began operating and carried passengers in and out until 1976.

After two attempts at selling the airport went bust, Mr. Taylor continued leasing it until his retirement in the 1960s. One of the reasons that he gave up flying and the airport was because of the death of his twenty-eight-year-old son in a crash with a marine jet from Cherry Point. At the time of his death he was a spotter for Beaufort Fisheries. Following Mr. Taylor's retirement, the airport was operated for a while by Steve Oakley of Morehead City. By 1964 Major Fred Seitz and his brother Bob signed a ten-year lease to operate Coastair, the Seitz Corporation. In 1966 they were bought out by Mr. Rodd, who continued to run the airport under the Coastair name. Dick Rodd of Havelock managed the airport until 1976, when Craig Willis of Morehead City took the reins.

When Craig Willis took over management of the Beaufort airport, he himself was a pilot taught by Bob Burrows. Willis's company was known as Air Flite, Inc., providing operations twenty-four hours a day, with rentals, charters, flight instruction, car rentals, sightseeing flights, maintenance and fuel. Air Flite leased a building from the county. Mr. Willis had been with United Airlines since 1963 and continued to fly for them from Washington, D.C. National Airport two or three days a week. As a flight instructor and FAS examiner, he was authorized to certify pilots of all grades. Most of the customers were charter, business and industrial.

Today, Seagrave Aviation operates the same type of services as Air Flite, Inc., did. Every now and then one can hear the low rumble of helicopter blades approaching and moving over the area, shaking and rattling houses, and we all know that the marine helicopter from Cherry Point, *Pedro*, has come to town! Many times it is merely a training exercise, but in some cases *Pedro* has been involved in search and rescue of lost ships and sailors offshore. Touch and goes occur as well for the new airship, the *Osprey*, which also can shake and rattle when overhead. Our military is nearby, and more and more jets are in the skies over our town, providing a sense of safety from harm.

ONE OF OUR OWN

Perhaps one of the most well-known names of persons who learned to fly at the Beaufort airport was Michael J. Smith, the astronaut. Mike Smith, the son of Robert and Lucille Safrit Smith, was born April 30, 1945. The Smith family owned a small farm on West Beaufort Road, raising chickens. Mike was the oldest of the four children. Brothers Pat and Tony still live on portions of the original farmland and have married and had their own families. Sister Ellen is married and living in Raleigh.

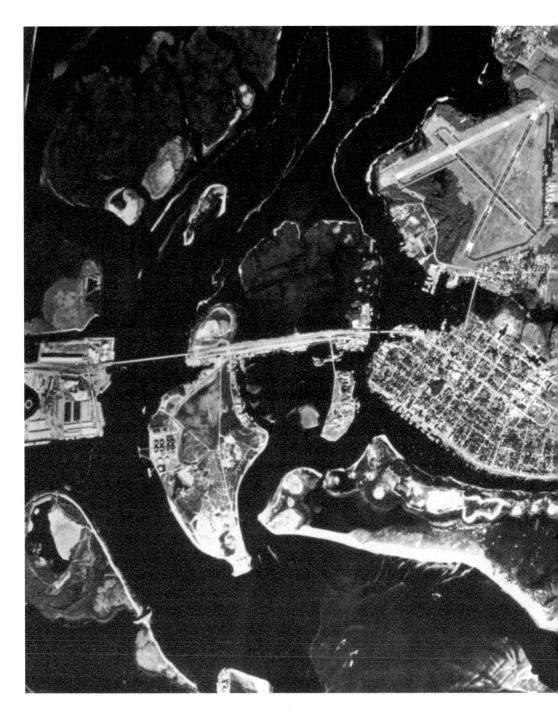

An aerial map of the airport and the town that is displayed in the office of the Michael J. Smith Airport. *Courtesy of the author.*

Photo of Michael J. Smith, pilot of the *Challenger* in 1986. *Courtesy of Tony Smith.*

The family home was close to the airport, and every evening the boys would run out to see the DC-3 fly over and land at the airport with wheels screeching on the runway. Apparently this was what sparked Mike's desire to learn to fly, become a pilot and then an astronaut. Mike soloed on the morning of his sixteenth birthday. In the afternoon he got his driver's license. He went on to get his private pilot's license before going to the Naval Academy. His career track was set to fly on a shuttle into space.

Information from a NASA news release gives an insight into the accomplishments of his goals. Mike graduated from Beaufort High School in 1963 and entered the Naval Academy, where he studied aerodynamics and received a bachelor of science degree in naval science in 1967. He then earned his master's degree after nine months at the U.S. Naval Postgraduate School in Monterey, California, in 1968. In May 1969 he completed navy aviation jet training at Kingsville, Texas, receiving his aviator wings. Assigned to the Advanced Jet Training Command, he served as an instructor until March 1971. For two years he completed a Vietnam cruise aboard the USS *Kitty Hawk*.

In 1974 he completed U.S. Navy Test Pilot School and was assigned to the Strike Aircraft Test Directorate at Patuxent River, Maryland, where he worked on the A-6E TRAM Cruise Missile guidance systems. In 1976 he returned to the U.S. Navy Test Pilot School and completed an eighteen-month tour as an instructor. From Maryland he was assigned to Attack Squadron 75, where he served as maintenance and operations officer while completing two Mediterranean deployments aboard the USS *Saratoga*. He flew twenty-eight different types of civilian and military aircraft with nearly five thousand hours of flying time.

Above: Photo of the crew of the *Challenger* in 1986. *Courtesy of Tony Smith.*

Right: Monument to the memory of Michael J. Smith at the waterfront on Front Street. *Courtesy of the author.*

The ultimate goal of Michael J. Smith was to become an astronaut, and in 1980 he was selected as an astronaut candidate by NASA. He completed a one-year training and evaluation period in August 1981, qualifying for assignment as a pilot on future Space Shuttle flight crews. He served as a commander in the Shuttle Avionics Integration Laboratory; deputy chief of Aircraft Operations Division; technical assistant to the director, Flight Operations Directorate; and was also assigned to the Astronaut Office Development and Test Group.

Mike Smith, a captain in the U.S. Navy, was assigned as pilot on STS 51-L and also as pilot for Space Shuttle Mission 61-N, which was scheduled for launch in the fall of 1986. The NASA release continues, "Captain Smith died on January 18, 1986 after the Space Shuttle *Challenger* exploded one minute 13 seconds after launch from the Kennedy Space Center." With him was Dick Scobee, the commander; three mission specialists, Ronald McNair, Ellison Onizuka and Judy Resnik; and two civilians, Christa McAuliffe, the teacher from New Hampshire, and Greg Jarvis.

Mike was married to Jane Jarrell of Charlotte. They had three children: Scott, born in 1969; Alison, in 1971; and Erin, in 1977. He received the Defense Distinguished Service Medal posthumously, as well as the Navy Distinguished Flying Cross and many others during his brief career. His brother, Pat, stated in an interview ten years after the tragedy, "He'll be a historic figure because he was one of the seven, but I think his main legacy is Carteret County and Beaufort and the people who knew him."

Two scholarships have been established in Mike's honor at the two high schools in the county, and to pay tribute to Mike, his first airport was renamed the Michael J. Smith Field. When you are walking along the waterfront in Beaufort, take a moment to stop and look at the monument, a memorial marker that serves as a reminder of this special citizen of our town.

Pilot trainer Burrows, now deceased, and other friends have all commented on Mike, and in an interview in the *Daily Reflector* of Greenville on the tenth anniversary of the loss of the Shuttle *Challenger*, the present-day manager of the Michael J. Smith Airport recalled his flying buddy, for they had taken lessons at the same time.

John Porter Betts is thanked for sharing the scrapbook he has kept about the airport and the history of the CAP at the Beaufort airport when it was just a mud and grass field. And Tony Smith is especially thanked for loaning me the newspaper articles from 1996, the NASA information and the photo of Astronaut Smith and the crew of Space Shuttle *Challenger*.

The Michael J. Smith Airport and county have leased property to Seagrave Aviation. The county rents and maintains twenty-three hangars for personal planes. It was from this airport that photographer Stoney Truett with pilot Frank Hauman made flights of the area around Beaufort and the town itself for this book.

A Stroll through History

Landmarks

Some of the people who owned property in the area in the early days didn't build any big houses or small cottages. When they returned to their homes in the northeastern part of the state, their names remained simply as part of a waterway or piece of land.

John Galland, along with his sister Penelope, was a stepchild of Governor Eden. In 1727–28, Galland purchased property from James Shackelford east of the Newport River. That property is what we know today as Gallant's Point, and the waterway running adjacent to it to the south and between the town's western edge and the marsh to the west is known as Gallant's Channel.

Christopher Gale was in the area of the county as well, purchasing land to the west of present-day Morehead City. Gale's Creek is named for this man, who also served as a vestryman and collector of customs at Port Beaufort in the 1720s. James and John Shackelford (or Shackleford) were also early purchasers of land in this area, especially that of the banks that today have their name.

Also of interest is the term Old Topsail Inlet. In the beginning of the town of Beaufort, settlers kept an active watch on the inlet to see what ships might be entering. At times it was pirates, the British or even the Spanish. But when the upper mast and sails appeared, a lookout would shout, "I see the top of a sail!" This became topsail and finally Topsail Inlet and then Beaufort Inlet.

Walking the Streets

Front Street

Among the most interesting houses built in Beaufort were those of the Duncans, Pivers, Davises, Buckmans and Potters. But a stroll through the history of Beaufort would not be complete without giving some brief history of several of the larger houses on Front Street, over and above the Duncan and Davis houses in the first block. These include

The Morse House, second block of Front Street. *Courtesy of the author.*

the Nelson, Sloo, Morse, Pacquinet, Ward and Easton houses in the second block of Front Street. The third block also contains some historic names, such as Borden, Fuller and Sabiston, which today are bed-and-breakfast places known as the Cedars and the Elizabeth Inn. The fourth and fifth blocks of Front Street are the primary business district of town, and the sixth contains the new Inlet Inn, part of the old Inlet Inn and the BB&T bank. We are now at the end of Old Town.

POLLOCK STREET

The beginning of New Town starts on the east side of Pollock Street and in that first block is the present-day post office. Next door is the Dr. Charles L. Duncan house, which was moved to this location to make room for the post office next door. In fact, the story goes that Dr. Duncan was in the bed on the second floor and watched the creek and island go by during the move. Next to the Duncan house is the Jones house and the last house in that block is the Wheatly house.

Pollock Street has some nice newer homes mixed in with some older ones in the first block. Also, the parking lot for the bank and part of the post office is in this block. The second block is where the town hall is located, and the old train depot is at the corner of Pollock and Broad Streets.

ANN STREET

On Ann Street we find many of the homes of the Buckmans, Pivers, Davises and Potters. In the first block of Ann Street we find the Beaufort Inn overlooking Gallant's Channel.

Front Street business district buildings on north side. *Courtesy of the author.*

On the south side in this block are the Buckman house, the Methodist parsonage and a Sabiston house. Opposite on the north side are the Chadwick, Piver, Beveridge, Piver, Hudgins and Piver houses. The north side of the second block begins with the original Davis house, St. Paul's Parish house, church and offices and the Arendell house. The north side of the third block has the three Leecraft houses, the Geoffroy house and the Captain's Quarters Bed & Breakfast at the corner of Ann and Turner. On the south side of the third block, at the corner of Orange and Ann, is one of the Potter houses, and next to it is the second Buckman house.

The fourth block of Ann Street on the north side is the present-day Baptist church, the Old Burying Ground and the Methodist church. On the south side is the Dr. George Davis house and others. At the corner of Ann and Craven Streets is the Langdon House Bed & Breakfast. There are many other lovely old homes in the next few blocks of Ann Street, but one must go to New Town before arriving at the other Potter houses, one of which is in the middle of the north side of Ann Street between Pollock and Marsh Streets, and the other two on the south side closer to Marsh Street.

BROAD STREET

Broad Street is interesting in several ways. It was originally where the town connected to the outside world by train. Today, on the property known as town point, is Gallant's Landing, a development of beautiful three-story homes built within the last few years. But when you look at the architecture of the rest of this street, you can see the difference between the homes of the wealthy on Front and Ann Streets and those of the less affluent working man. Going east in the first block are many of the smaller cottages, most built

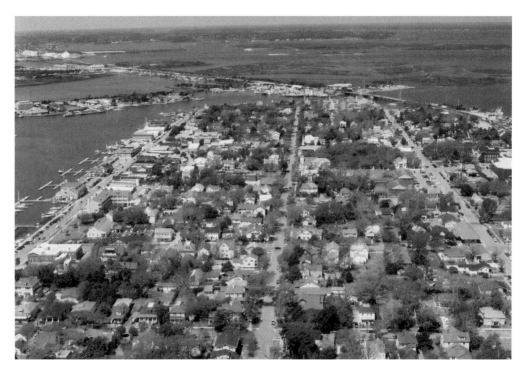

Aerial view looking west over Ann Street, with Broad Street to the north, Piver's Island, the causeway, Newport marshes and Town Creek in the distance. *By Stoney Truett.*

in the mid-nineteenth century, with the exception of the 1700s Walpoole house on the corner of Moore and Broad Streets.

On the north side of the second block is a brand new house that replaced a historic cottage, followed by more of the smaller cottages of the nineteenth century. On the south side are the cemetery of St. Paul's Church and two additional homes. The third block continues with the smaller homes and cottages, while the fourth block is where we find county offices, the courthouse complex and Purvis Chapel at the corner of Broad and Craven Streets.

CEDAR STREET

Cedar Street, where the highway enters Beaufort, was at one time under water, as was the north end of Moore Street. The edge of Town Creek wound around from Gallant's Channel, across Moore Street and Cedar Street, along the end of Pine Street and continuing on until it ended in a small streamlet at about Marsh Street. Today Moore Street is connected to Cedar, and Turner Street crosses over Town Creek to connect with West Beaufort Road. The houses on Cedar Street were fishermen's homes in years past. Many have been purchased and renovated in the past few years. Today this street is where some businesses have been built and black churches are located.

Cross streets also offer a look at the steps from rich to poor, so to speak. The first and second blocks of most of these streets contain larger homes. The third block begins to see

some of the small cottage-type houses, such as those found on Broad Street. The blocks beyond Cedar Street are primarily the fishermen-type cottages and most are within the black community. Just after the Civil War, the division between black and white became more prominent, and the part of Beaufort north of Cedar Street, including Pine and Mulberry, was where the black people settled. The white citizens remained to the south of Cedar Street.

MOORE STREET

Moore Street is the first of the cross streets. In the second block is the part of the cemetery where a Piver house was originally located and the second James Davis house. It is also probable that James Davis built the house next to his in the second block. In the third block is the house that was purchased and lived in by one of the Piver men.

ORANGE STREET

Orange Street's third block contains two of the Piver houses, one of which was moved to its present location and the other that was built where it remains today.

TURNER STREET

Turner Street's first block is primarily business and also is home to the Beaufort Historic Association restoration grounds. The second block on the east side has the Franklin Lodge—a school and home in the nineteenth century—the library and the IOOF brick building built while the fort was being built. On the west side is the newest bed-and-breakfast, Anchorage House, as well as the Gibble-Delamar Bed & Breakfast. In the third block we find Courthouse Square to the east, with a Duncan house among others on the west side. Crossing Cedar Street and to the corner of Pine and Turner is another of the Piver houses.

CRAVEN STREET

Craven Street's first block has one or two houses on the east side and several on the west, including the Langdon House Bed & Breakfast. The second block on the west side contains the Ann Street Methodist Church offices, another entrance to the Old Burying Ground and Purvis Chapel AME Zion Church. On the east side is an older home and the Social Services brick complex.

QUEEN STREET

Queen Street's first block is the home to two restaurants, the Beaufort Grocery Company and the Blue Moon next door, on the west side. On the east side is the Pecan Tree Inn Bed & Breakfast and also another Davis house.

The remaining cross streets in New Town are Marsh, with some lovely older homes mixed in with some of the smaller cottages, and Live Oak Street, where businesses and homes sit side by side.

Early Settlers and the Houses They Built

Duncan Houses

The Duncan houses are some of the finest built on Front Street in Beaufort. Family history states it was John Duncan who came to this area from the West Indies in 1728 and built the house at 105 Front Street, at the west end of the street, incorporating architecture from the islands. However, it is not until 1832 that we find a Duncan actually owning the property on lots 110 and 111 Old Town.

Prior to this date, according to the town record book 1774–1877, the clerk was ordered to make out two deeds to Edward Fuller for the "two front lots in Old Town, Nos. 110 and 111." Early court minutes of 1768 state that Edward Fuller was deceased and his wife, Hannah Fuller, exhibited his last will and testament. She was executrix while William Robertson and Edward Fuller, perhaps her son, were executors.

Deeds beginning in 1790 show the two lots, with their improvements, including the house on 110, were sold at public venue to Robert Read for thirty pounds total. These were the lots that Edward Fuller took up and improved in his lifetime. Within a few months Robert Read sold the two lots with their improvements to William Dennis Jr., the sheriff, who had sold Read the lots in the first place.

In 1804 Nathan Adams acquired half of lot 111 Old Town with all the improvements through the will of William Dennis, the late sheriff, who sold the lot to his daughter, Elizabeth Davis, who was married to James Davis, the builder of houses in Beaufort. Six years later, in 1810, Nathan Adams sold James Davis the other half of lot 111 Old Town, which was the southeast part. The lot was of a rectangular form, according to the deed to Elizabeth, and she was to get the northwestern part of the lot.

In 1820 James Davis sold all of lot 111 Old Town to Benjamin Tucker Howland, except for forty-two feet of the northern part, which he and Elizabeth had sold to Elijah Canaday in 1816. Howland sold lot 111 Old Town to Thomas Duncan Jr., except for the forty-two feet on the north part, together with the dwelling house, storehouse, kitchen, outhouses and improvements. It was not until 1854 and 1855 that Thomas Duncan acquired lots 110 and 111 Old Town from David and Needham Canaday, which they had inherited from their grandfather, Elijah.

According to the census figures, Thomas Duncan and his family are not shown in Beaufort until 1800, and the Howland family does not appear until 1820 in Beaufort, while the Canaday family was here in 1810. In the tax listings Benjamin T. Howland and Elijah Canaday Sr. owned lot 110 through 1830, and in 1866 and 1871 it was in the hands of A.C. Davis, son of James and Elizabeth. Lot 111 was also in the Howland and Canaday names through 1830, with Thomas Duncan owning it in 1866 and 1871.

By circa 1880, when Gray did his map of Beaufort, William B. Duncan is shown as the owner of this property.

Thomas Duncan was married to Benjamin Tucker Howland's daughter, Elicia, and when James Davis sold lot 111 to her father the cost was $1,000. When Benjamin sold lot 111 in 1832 to Thomas Duncan he was paid $600. Lot 111 is the larger of the two lots, with 110 to the north.

105 Front Street

The architecture of the house at 105 Front Street is reminiscent of Nassau, St. Kitts and Bridgetown in the Bahamas. The double-deck porch has turned posts in the form of Doric columns, similar to those found in the Spanish islands. When first built, the house was half the size it is today. The western side was added by Thomas Duncan as a ship's chandlery dealing in turpentine, molasses, rope and other commodities. Ships' masts support the ceiling in this portion of the house. The triple chimneys are due to the great length of the structure.

From the wording in the deeds in 1816 and 1820, there was a dwelling house and a storehouse on this lot, along with the usual outbuildings and kitchen. It is very possible that a Duncan built the original house, although the records are not clear about that. But we do know that a Thomas Duncan, perhaps the captain, added to the house by building the chandlery. And over the years since Thomas Jr. bought the property and his son, William Benjamin, owned it in 1880, the dredged material from the deepening and widening of Gallant's Channel has increased the property.

In 1984, the Duncan house was the home of Mrs. Sarah Rumley Duncan, the wife of Julius Fletcher Duncan Jr. The house has recently been sold out of the Duncan family after more than 175 years.

505 Front Street

Over the years, Thomas Duncan Jr., son of the captain, bought and sold property. The house located on the eastern half of lot 12 Old Town, at 505 Front Street, was most likely built by Thomas Duncan circa 1842, perhaps for his son, William Benjamin Duncan (1836–1911), who was married to Sara Jane Ramsey (1835–1867) and had eight children. By 1854 the home was an academy. William Benjamin and Sara Jane Ramsey Duncan's son, Thomas Isaac (1860–1938), married Laura Nelson and in 1938, Laura C. Nelson gave her daughter, Lena N. Duncan, her home on Front Street where she was residing, with all household and kitchen furniture.

This house is known today as the Carteret Academy and also as the Lena Duncan house. According to an article in the *Carteret County News-Times* in 1970, the house was the Beaufort Female Academy of 1854, with school held in the basement. Family, teachers and students lived in the floors above. The basement was made of bricks and the house entrance was on the second floor. The porch steps are the primary feature of this building, as well as the fact that the porches of the second and third floor do not run the entire width of the house. The house was purchased in 1989 and underwent major restoration, including raising it to meet flood insurance requirements, turning the first

Copy of a postcard of east Beaufort waterfront, Dr. C.L. Duncan house at the left. *Courtesy of Virginia Duncan Costlow.*

floor into living space for the new owners, updating plumbing and electric and building the brick wall surrounding the structure.

The Duncan family lived in this house for one hundred years. Lena Nelson Duncan never married and was a wonderful teacher, according to some of her former students still living in town. It has been said by these students that one could visit Miss Lena any time and she would invite you in for cookies and tea. What a wonderful memory.

515 Front Street

The next Duncan house, two structures to the east at 515 Front Street, was built on parts of lots 10 and 11 by Thomas Duncan between 1855 and 1865. This house may have been built for another son, Thomas L. Duncan (1843–1880), who married Annie Leecraft Perry (1844–1877). Thomas Duncan Jr. bought the property from Needham Canaday for $40 in 1855. Thomas Lucas Duncan married Annie Leecraft Perry in 1865. Their son, Charles Lucas Duncan (1872–1937), in 1895 purchased nine feet of the eastern part of lot 11 Old Town for $100. In 1900 Charles Lucas Duncan sold the property to Christopher D. Jones for $1,500, which included the water lot across the street. It was sold again in 1906, and in 1924 the Way family acquired the property and the Thomas Duncan house.

Today the house is a business, Taylor Creek Antiques. The entry door is to the left on the full-length porch, with a hallway running to the rear room, which could have been the dining room. On the east of the hallway are two fairly large rooms that most likely served as the living room and the parlor. The kitchen would have been separate when the house was built, but is now incorporated to the back of the first floor. The stairway to

Dr. C.L. Duncan house today at 705 Front Street. *Courtesy of the author.*

the second level led to the bedrooms. Additions at the back of the house were made most likely following the sale to the Way family. This part of the house has gone into disrepair, and in recent months the property has been purchased. The new owner is planning to move the Thomas Duncan house to a vacant lot on Orange Street and build a new brick three-story combination business and residence.

705 Front Street

Prior to the sale by Charles Lucas Duncan in 1900, he had a house built on lot 1 New Town. Today this house, 705 Front Street, is located to the east of the post office, although it was not built in this location. The site of the original location, lot 1 New Town, was where the front lawn of the old Atlantic Hotel was before it was destroyed by a hurricane in the late 1800s. Dr. Lucas, his wife, Virginia Clyde Mason Duncan, and their children, Annie Virginia, Grace and Clyde, moved into the new house. When the government purchased part of the property for the new post office, the story goes that Charles Lucas was sick in bed on the second floor when the house was moved to the eastern part of the lot, where it sits today. As he looked out the window, he could watch the creek and the island opposite going by.

This Duncan house is large and beautiful, behind a stone fence with beautifully landscaped gardens and front yard. When the house was built it was overlooking the waters of Taylor's Creek, until Front Street was extended in the 1900s. Daughter Annie V. Duncan married Bryant Council Brown in 1924. They lived in the family home next to the post office following the death of her father in 1937. B.C. Brown died in 1967 and Annie V. in 1990. Today the house is being lovingly cared for by the new owners, who purchased the property from the descendants of Charles Lucas and Virginia Clyde Mason Duncan following the death of Annie Virginia Duncan Brown.

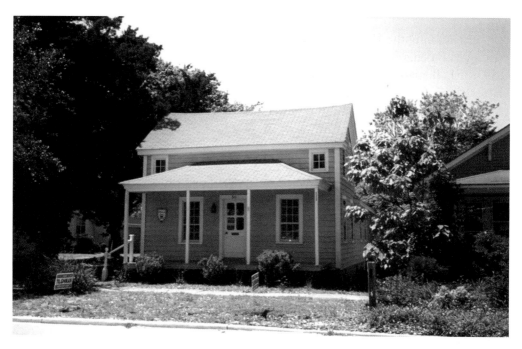

The W.B. Duncan house in the third block of Turner Street. *Courtesy of the author.*

311 Turner Street

Another Duncan house is located at 311 Turner Street. According to a history by the present owner, William B. Duncan and his second wife purchased the property on the eastern part of lot 145 at a tax sale in 1869, although according to the record they were not married until 1873. William B. had been married first to Sara Jane Ramsey in 1856, and perhaps it was during this first marriage that the lot was purchased.

The owner's history continues with the fact that there was no record of a house on the lot, but it is believed that the house may have come from the Diamond City area of Shackelford Banks. In 1886, the Duncans deeded the property to John H. Springle. In 1911 Springle's heirs deeded it to J.D. Parson, who left it to his daughter, Mavis P. Glancy, for her life. The present owners of the property acquired the house and lot from Parson heirs and restored the house for use as their son's attorney's office.

This house is a small cottage with a covered front porch. During the past several years the house has been rented to different businesses as the attorney has moved on.

DAVIS HOUSES

119–125 Front Street

Back at the beginning, near Duncan Green and the house of 1790, we find what is called the Davis House, next to the Manson House. The house is located on 119–125 Front Street and was originally three houses. Part of this house was built in 1774 on lot 32 by Frederick Warner. In the tax list of the early 1800s this property is owned by William R.

Bell. It is not until the 1866 tax listing that the ownership is in the hands of a Davis and the estate of Benjamin Tucker Howland.

In 1854, Benjamin Tucker Howland sold the western half of lot 32 Old Town to his daughter, Elizabeth T. Davis, wife of Christopher A. Davis. Within a few years Elizabeth T. Davis purchased the eastern half from James Howland, perhaps her brother. Research is ongoing into this property, as it has been purchased recently, restored and converted into condominiums. But apparently two houses were built adjacent to the Warner house, most likely by Howland. On the circa 1854 chart there are three houses in this location, but on the Gray's map three houses appear with the name of Sarah Davis written. Sometime later, the three houses were joined by porches, particularly the long front double porches. A dining room and kitchen were added to the middle of the three houses. This can clearly be seen on the Sanborn Insurance map of 1913.

By the 1890s Beaufort was gaining a reputation as a coastal resort and watering place. Local citizen Thomas H. Carrow wrote of this transition in his 1948 article in the *Carteret County News-Times*, titled "Memories of Beaufort in the Nineties." He stated that the primary hotels or eating houses were the Davis house at the west end of Front Street, run by Miss Sara Ann, as well as Miss Emma Manson's house just west of the Davis House. He stated that on a summer's evening, both the Manson House and the Davis House porches were filled with happy boarders enjoying the south wind that always seemed a little more delightful in Beaufort.

The Davis House was purchased sometime in the 1900s by Duke University to provide housing for visiting investigators and graduate students, along with their families. In the 1970s these apartments were filled and it was a delight to gather on the porches during the summer taking in the refreshing southerly breezes, just as boarders had done in the late 1800s.

127 Front Street

Next door to the Davis House Inn and Boarding House, at 127 Front Street, was the John D. Davis house, built in 1873 at the corner of Moore and Front Streets. John Dixon Davis was the son of John Stancil Davis Jr. and Rosamond Harker. His roots go back to William and Mary Wicker Davis, as do many of the Davises in this county. The house is typical of many houses in Beaufort, with double porches across the front. It is possible that this is one of the many houses built by James Davis in 1812. At the present time, the house remains in the Davis family and is used as a rental property.

201 Ann Street

To continue the tour of the Davis houses, we must go north on Moore Street to Ann. It is at the northeast corner of this intersection that James Davis built his first home.

James Davis was born in 1780, the eldest son of Joseph Wicker and Susanna Stanton Davis, also related to William and Mary Wicker Davis. In 1803 James Davis married Elizabeth Adams, the daughter of Nathan and Mary Adams. This couple acquired the Duncan property on lot 111. Prior to selling the property in 1820, James Davis

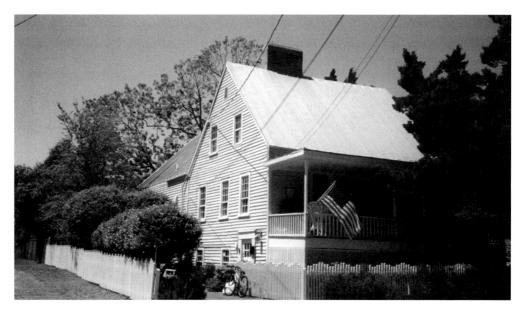

The James Davis house on Moore Street. *Courtesy of the author.*

built a house for his family on lot 76, at the corner of Moore and Ann Streets, where it remains to this day. In 1817 James purchased the lot for unpaid taxes and built his new home.

The Davis house, circa 1817, is built of native longleaf heart pine, with double porches across the entire front. Built according to a floor plan used by James throughout his lifetime in building other houses, the entryway is to the west side of the lower porch with a side hall and staircase to the second story. To the eastern side of the hall are two rooms, one the living room or parlor, with the second perhaps a dining room. The kitchen was separate, as was usual in the 1800s. The second story contains the bedrooms, and above that is an attic space. In the past few months, the balusters and railings have been changed due to severe damage to the porch floors. No longer are they the fancy cutouts that are seen in the photo. Today they are like most of the porch railings and balusters on other houses in Beaufort.

The house was sold in 1826 to Captain John Hatch Hill, whose widow, Abigail, deeded the eastern two-thirds of the lot to the vestry of St. Paul's Church in 1857 for the building of the new church. This house also served in the early 1900s as the home of Miss Nannie Geoffroy, as well as a part of St. Paul's School, adjacent to Watson Hall. Students practiced their piano lessons in the parlor, while others might have been in the infirmary to the rear of the house. The kitchen, by this time connected, served as the repository of barrels full of clothing donated to the needy. But the most interesting memory is of Miss Nannie's parrot sitting on the front porch screeching to passersby who may be on their way to Morehead City across the new causeway that began at the west end of Ann Street.

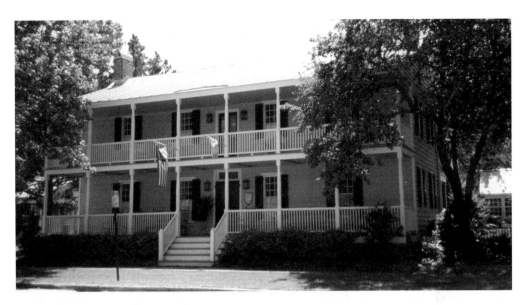

The Buckman house in the third block of Ann Street, south side, recently restored by the owners. *Courtesy of the author.*

215 Moore Street

If you stroll up Moore Street about half a block you will find the second home of James Davis and his family. Sometime before 1826, James Davis had built another house for his family on lot 45 Old Town in the second block of Moore Street. In building this house he placed a partially underground basement below the living quarters to serve as his cabinet shop and to store the tools he needed for constructing some of the other houses. He also used the concept of a central chimney with four fireplaces.

The main entryway to this house is a center door into the living room with a small room to the north side, perhaps a parlor. Beyond the living room, with its fireplace, is the dining room with its fireplace. The stairway to the second floor is to the north of the dining room. A kitchen would again be separated, but perhaps connected by a "dog run." The second floor has two bedrooms with fireplaces, and there is a small attic at the very top. The original oyster shell plaster walls remain, as do the old beams, the brick and the pine floors.

This house was purchased in the 1990s and today is beautifully restored, with an addition to the back containing the new kitchen and family room. The basement has served this family as guest quarters with a pub and today it is a rental apartment.

A side note to these two houses known to be built by James Davis: there are others that may have been built by him as well, including the Hudgins house on Ann Street between two Piver houses, the Longest house to the north of his second home, the Adams house and Alexander house in the first block of Moore Street and the Potter house in the 700 block of Ann Street. As you stroll through the town of Beaufort, you might be able to spot others as well, since most of the Davis houses were built using the same type of plan, especially for the double porches with either side or center entryways.

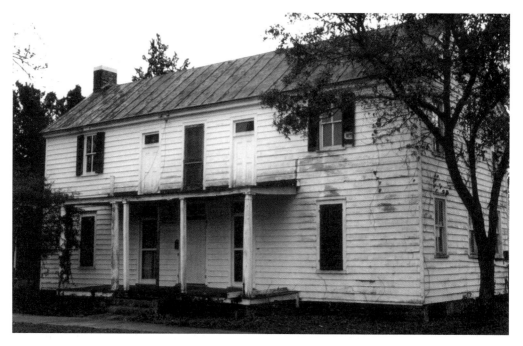

The Buckman house, before restoration. *Courtesy of Joe and Marianna Hollinshed.*

We now go to the first block of Ann Street to the west. There we find the first of the Buckman houses, as well as the beginning of the Piver houses.

THE BUCKMAN HOUSES

114 Ann Street

The earliest of the Buckman houses was built with a basement and family quarters beginning on the second story. The basement is built of brick with the upper story being wood-framed and sided. Built in 1845 on land that may have been part of the marsh area purchased by Peter Piver in the 1700s with water nearby, it is possible that the location had something to do with the plan of the house. Edward Buckman built the house for himself and his wife, Eliza. Although it was constructed later than many of the other houses nearby, this house is entered through an exterior stairway that rises to the landing under a small porch.

When the house was inherited from Mary Catherine Buckman Taylor in the 1900s, the owners turned the basement into the living area and made sleeping rooms of the second story. Mary Catherine Buckman had been born in the house in 1860 and lived there until she married N.W. Taylor. Heavy beams can be seen in the newly converted living area, with mortise and tenon joints still visible. A massive central chimney serves three functioning fireplaces, one in the living room, one in the kitchen area and one in the master bedroom on the second floor. A short stairway from the living area to the second floor gives access to the three bedrooms that were created there. The rooms are small with high ceilings.

306 Ann Street

There may be no connection between Edward and Eliza Buckman and the next Buckman house, which is located at 306 Ann Street. In 1864 a Guy Buckman of Beaufort County owned lot 64 Old Town, on which this structure was built. Buckman apparently mortgaged his properties and the lot was purchased by David B. Wharton, who was married to Susan Davis, daughter of James and Elizabeth Adams Davis. Apparently the lot had been owned early on by a Hackburn family who never lived in a house on this lot.

Between 1848 and 1852 the value of this property was $600 and the property was owned by the mortgagees of Guy Buckman. The house, from what can be determined through research and onsite investigation, was most likely built in 1856 by Guy Buckman. The Sanborn Insurance map of 1885 shows that there was a single-family, two-and-a-half-story house on this lot with double front porches and a single-story back porch. By 1893, the single-story back porch had been altered by removing a center section. An addition of a small single-story shed is also shown, as well as another two-story shed to the east. There was little change to this piece of property by 1898.

In 1904 dramatic changes took place to this house. The main portion was divided into two equal living sections. The front porch was still two stories but decreased in width and divided into two separate sections. The back east end small porch became a single-story large addition running north and south with a porch on both the east and west sides and extending across the back of the house to join the west end small porch. A one-story small shed and stable were also indicated on the insurance map. By 1908 and 1913 the two small front-story porches had become one story and joined, but were not running the full length of the house.

Research says that this house served as a hotel or hospital run by Susan Wharton during the Civil War. It was later purchased by Benjamin James Bell and was known as the Jennie Bell house by 1900. It was then owned by the Merwin family, whose daughter Elizabeth designed the first plaque that is seen on many of the historic homes today. By the time the property was sold in recent years, the house was dilapidated, and Elizabeth was living in one room on the second floor. The new owners have restored the house to its former glory.

THE PIVER HOUSES

Peter Piver and his family came to Beaufort in the mid-1700s. According to family history, they were and are today descendants of French Huguenots. Apparently problems with the king in France made life difficult in their home country and several families left to come to the New World, settling in New York, Virginia and North Carolina. Peter Piver was a bricklayer, and in 1750 he purchased land from John Shackelford in the county of Carteret. The description of the land is unclear as to the exact location, but it did include ten acres that were part of a larger tract. The interpretation by the family says that this property was at the west end of town from Moore Street, including the marsh that eventually became known as Piver's Island.

The Piver house, 119 Ann Street. *Courtesy of the author.*

A deed in 1764 to Piver and William Robertson was from Charles Dickinson, the son and heir of John. This deed actually does give a better definition of the area, stating that it includes approximately fourteen acres commonly known as Town Point. This piece of land began at the side of the marsh joining the town land, running west to the mouth of the Newport River, then up the river to the marsh adjoining the town along the bounds to the first station. The land had been purchased in 1740 from Charles Cogdell by John Dickinson. With these two deeds it would appear that Peter Piver owned a good portion of the western part of Beaufort, including the marshland.

In 1770, a map of the town of Beaufort was drawn by C.J. Sauthier, who also mapped New Bern and other towns in the province. It is presumed that he went by boat along the waterfront making notes of the houses and other significant landmarks. At the extreme western edge of the town is the marsh adjacent to what might be called the mouth of the Newport. There is a sluice of water running between that marsh and what was the mainland of the town. This is most likely the marshland that, over the years, migrated to the south a bit. Dredging the sluiceway in the 1800s also added to the building of this island, known today as Piver's Island.

119 Ann Street

The Peter Piver house, circa 1750, passed down to Daniel Piver at Peter's death in 1794. According to one history, the Peter Piver house was built at the corner of Moore and Ann Streets, but another one says that Peter Piver built his house near the water's edge with a boat dock in the side yard and a beautiful view. It would make more sense that he would build a house closer to the water to be nearer Gallant's Channel with the marsh area and the sluice running south, giving him water access for his boat. Today this house is located at 119 Ann Street and is in the Chadwick family.

The house has a steep gable roof that extends over the front porch. A central hall, with a living room to the left and a small bedroom to the right, leads to the covered porch that formerly went to the detached kitchen. Also on the right is the small, narrow stairway that leads to the upper level, where there was a small room at the top of the stairs known as the "cradle room." Today this is an open space with a larger bedroom on the west side. In each of these rooms can be seen the small doorways that can be opened to allow airflow when needed. The roof of the front porch has a wooden insert that would be removed for this purpose.

A history written by a former owner states that this house was built by boat builders and nothing was absolutely straight or square. This was the way with most houses built in this time period. Rafters and studs were pegged, and hand-wrought nails kept the heart pine floorboards in place. Original plaster, made from oyster shells, horsehair and lime, was applied to the hand-split laths. Windows consisted of nine over six panes, many with the handmade irregular glass. The front and back doors were wide and heavy, held together with smaller wooden pegs. Ballast stones were used in the piers and the chimney was free-standing.

As with many of these original homes built in the late eighteenth century, structural changes have been made by the next generation of owners. In 1825 the back porch of this house was turned into a two-room addition, the kitchen was attached and the living room became a parlor. A dining room was also added. Outlying changes have been made as well. No longer does the house sit at the edge of the water. Landfill has extended the shoreline many hundreds of feet to the west. In the 1850s, Robert W. Chadwick married Mary Noe, and her father built the large two-story house next door on the west side. During the late nineteenth century Mr. Chadwick ran a school for boys from the Outer Banks. As they needed accommodations for their stay while at school, the second floor of the Piver house was turned into a dormitory.

Over the years many families have lived in the Peter Piver house. Among them were the Potters (a brick mason who worked on the fort), Noes and Shaws. The present owners are the son, and his wife, of the owner who wrote the wonderful history about the house.

125 Ann Street

The George Piver house, circa 1786, at 125 Ann Street, was most likely built by Peter Piver for either his son George or grandson George, son of Daniel and Jane. This house also has the steep gable roof that covers the front porch, which was the back porch when built. There is no ceiling on the front porch and one can see the two small window sashes that can be opened from the upper floor to allow airflow. Originally there was a steep, narrow stairway in the interior of the front room leading to the jump above. Today the house, owned by John and Virginia Costlow, is two apartments and has an exterior stairway leading to a second-floor doorway.

131 Ann Street

The Jesse Piver house, circa 1786, again may have been built by Peter Piver for another son, or for his grandson Jesse, son of Daniel and Jane. This house is, as with the other

The Piver house, 304 Orange Street. *Courtesy of the author.*

two on lot 41, a story and a jump with a central entry door into a small living space. A stairway to the upper level is located near the back of the house, which today is part of the kitchen and eating area.

It is interesting to note that each of these three Piver houses is in the same block on the same side of the street, and they are separated by one house between each. Between the Peter Piver house and the George Piver house is the Beveridge house and between the George Piver house and the Jesse Piver house is the Hudgins house.

304 Orange Street

The Peter Piver house, circa 1786, was originally built on lot 96 Old Town in what became the cemetery of St. Paul's Church. It was built near Moore Street in the western part of the lot. In 1817 William R. Bell purchased the lot at auction from the town. In 1836 he sold the western half of lot 96 Old Town with the house to Mahala Willis. In 1849 Mahala wrote her will and gave the lot and house to her two sisters, Nancy and Dorcas. It remained in the family until 1857, when Dorcas sold the lot, with lifetime rights, to the Reverend David Davis Van Antwerp, the priest at St. Paul's Church.

Thomas Duncan was the executor of the estate of Mahala Willis, and since her sister Dorcas had moved out of the house, Thomas Duncan had it moved to the southwest corner of Broad and Moore Streets, next to Susan Piver Longest's house. It remained in that location from the 1880s to early 1900s, when the house was sold to a member of the Johnson family, who moved it to the Orange Street location.

Several years ago, the house caught fire and was nearly destroyed. New owners, however, rescued the house and restored it to its original character and flavor. The small living space in the front is where the stairway to the jump rises to the second level. A

William Jackson Potter and Elizabeth Davis Potter, circa 1880. Courtesy of great-granddaughter Catherine Potter Stephenson and the St. Paul's Church Heritage Committee.

small room beyond has been transformed into a dining area, with the kitchen to the back. When the house was first built, it most likely followed the same pattern as the other Peter Piver houses built at about the same time.

313 Orange Street

The Joseph Piver house, circa 1829, is known as a story and a jump. One enters into the living room, with a small room to the south that could be a bedroom or sitting room. Beyond the living room is the dining room, with another room to the south of that, and the kitchen continues to the back. In the living room is a door that leads to the narrow, steep steps that rise to the jump, which is open. A window overlooks Orange Street from this upper room. The house was presumably just one room deep when built, with a covered porch on the back. The kitchen would have been separate.

420 Turner Street

The Jesse Piver house, circa 1825, located at the corner of Turner and Pine Streets near Town Creek, was built on lot 184 Old Town by the son of Daniel Piver. By 1866, W. Howard Piver, son of William who originally purchased the lot in 1817, owned the lot and the house. William was probably another son of Peter Sr. and brother of Daniel.

This house, too, is similar to the others in that the main entryway is in the center, going directly into the living space, with a narrow, curving stairway to the second level. The house

has recently been raised on new piers due to an accident with a car that jolted the house off the original ones.

THE POTTER HOUSES

In 1827, William Jackson Potter came to Carteret County as a brick mason. He was the son of David and Mary Adams Potter of Maryland. He liked the area and stayed, living in Beaufort. In October 1828 he married Elizabeth Harris Davis, the daughter of James (the noted house builder) and Elizabeth Adams Davis. The Potter family grew with the addition of ten children. William Jackson served on the first vestry of St. Paul's Church, although his wife was a Quaker, and eventually the family joined Ann Street Methodist Church.

707 Ann Street

William Jackson Potter bought lots 32 and 59 New Town in February 1830. While he was buying the lot on which their house was to be built by his father-in-law, William Jackson and Elizabeth lived in a house on lot 66 Old Town, known today as the Forlaw house on the south side of the second block of Ann Street. James Davis sold the eastern half of the lot to his daughter, as she would better maintain it. The deed mentions premises, but it is possible that James built the house.

In 1834 William Jackson "sold" his properties at Core Creek, the New Town lots and the east half of 66 Old Town, along with livestock, to Joel H. Davis for one dollar, to be sold to pay debts. Apparently this was simply a loan and the Potters maintained ownership of the properties, for in 1845 William J. and Elizabeth H. Potter sold the eastern half of lot 66 Old Town to John H. Forlaw, with appurtenances.

In 1872 William J. and Elizabeth H. Potter sold lot 59 New Town to James Hollister Potter, their son. Six years later, James and his wife, Nannie Murray Potter, sold lot 32 to Mary W. Davis and Sallie A. Davis, daughters of their grandparents who had never married. Again, this was a "loan" that would be void if the Potters paid it off. In 1894 J.H. and wife Nannie M. got a loan from a bank, using the lot 32 New Town property as collateral. They renewed the loan in 1897.

Thus the house that James Davis built for his daughter, Elizabeth, and her new husband, William Jackson Potter, in 1830 was still in the family at the turn of the century. Onsite observations made at the house in 1992 indicated that the laths were cut with frame saws and there was no ridgepole. The roof may have been steeper when built, and the L on the back was added several years after the main roof was shingled with hand-split shakes.

The original house ended at the west bedroom, and the steps came up to the east front bedroom on the second story. The door casing on the east end bedroom was original and the east side window was narrower, perhaps where a hearth had been. The bathroom was added in the 1920s, as was the fireplace. Windows were in place before the porch upstairs was added. The dormer was added to the addition when the porch was added on the front. The back kitchen was added later. Ballast stone was used to hold the sill

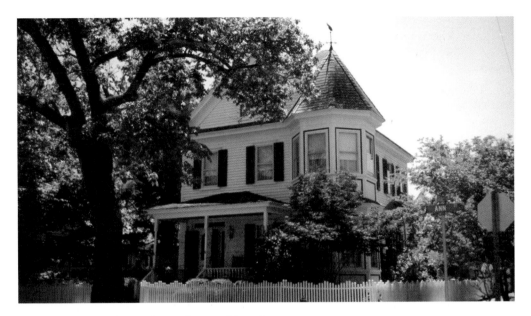

The Potter house, 300 Ann Street. *Courtesy of the author.*

across the front, and there were three courses of brick above that. There was a cistern centered under the rear of the original house.

Again, this is a James Davis house with a center hall and entryway, rooms on either side and a stairway to the second floor. And since William Jackson was a brick mason, he most likely did all the brick work under and in the house. The house is on the circa 1854 chart of the town, in the center of the lot with a structure directly to the north, most likely the kitchen. The house remained in the Potter family until it was sold in the 1990s by descendants. The house today is used as one of the new bed-and-breakfasts, called the Ann Street Inn.

300 Ann Street

James Hollister Potter (1847–1938), a son of William Jackson and Elizabeth Davis Potter, married Nannie Murray in December 1870. They had twelve children, including Halbert Lloyd Potter (1872–1972), who was in the wholesale fish business and was married in 1899 to Etta Davis (1880–1969), a daughter of James C. and Laura G. Davis. In November 1901, Halbert L. Potter bought a part of lot 64 Old Town from B.J. Bell and his wife, Sarah D. Bell, the owners of the Guy Buckman house. This part lot is at the corner of Orange and Ann Streets and is 50 feet on Ann, 110 feet on Orange. Halbert and Etta had a son, James Davis Potter, who married Frances Felder.

The house, built as a wedding gift, is described as predominantly Victorian in style but with a floor plan identical to the Greek Revival–style Leecraft, which is across the street where Etta Davis was born. The entry door is to the side of the front, primarily as there is a turret at the northwest corner of the house. The hall continues to the back of the house, and the stairs rise in the hallway. The front room where the turret rises is the

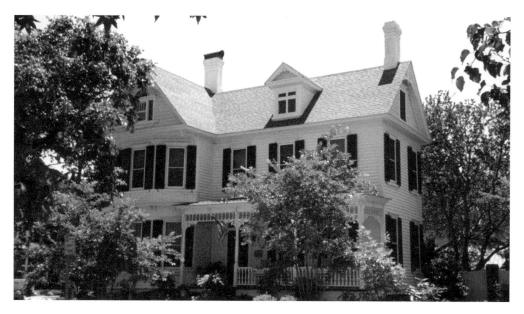

The Potter house, corner of Marsh and Ann Street. *Courtesy of the author.*

living room and beyond is the dining area. Sold several years ago, the owners have kept the house as it was when built.

716 Ann Street

Two other Potter houses are located nearly across the street from the original family home on lot 27 New Town at the corner of Marsh and Ann Streets. They are side by side. One was purchased by J.H. Potter in 1899 for sixty dollars. In a dispute with a descendant of the original owners of the property, J.H. Potter was the highest bidder and in 1901 received the deed to the property. This is the same J.H. (James Hollister) who was married to Nannie Murray and dealt with the other family properties.

In 1904, J.H. and Nannie Potter sold the corner piece of the lot to their son, William Van Buren Potter, born in 1875. The property was 110 feet running south along Marsh Street, and only 99 feet, or half the length of the lot, on Ann Street. It appears that they sold the westernmost part, which was 60 feet, to someone else, and in 1924 sold the middle part of the lot, beginning 74 feet from Marsh Street and continuing 25 feet on Ann Street, to J.H. Potter Sr., William Van Buren's father. A daughter, Nannie Murray Potter, named for her mother and born in 1884, never married.

The W.V.B. Potter house was built circa 1903. It is a Queen Anne–style house similar to the Hal Potter house at the corner of Orange and Ann, in that it too has a turret or bay, although in the northeastern corner. According to an article written in 1985, the house was built from materials salvaged in part from a shipwreck off Portsmouth, Virginia. A porch with gingerbread runs from the bay to the other end of the house along Ann Street, with the entryway near the turret. The house is two stories with an attic. The stairway to the second floor begins in the entry hall, which stretches to the back of the house.

William Van Buren was married in 1903 to Zylphia Cox Darden, and he was in the wholesale fish business. They had two children, William Hollister Potter, born in 1909, and Alice Darden Potter, born in 1905. A conversation with a descendant of the Potters confirms that James Hollister Potter Sr. built the house for his son as a wedding gift. It was sold by the family in 1984, and the major change inside was to enlarge and open up the kitchen area. It has recently been sold again and the new owners are keeping it just as it was.

712 Ann Street

The house next door was most likely built in 1910 as a wedding gift, also from James Hollister Sr. for his son, James Hollister Potter Jr., who was married to Ada Matilda Rhodes in April of that year. James Hollister Jr. was the owner and operator of Potter's Grocery Store for seventy years. According to a conversation, James Hollister Sr. never deeded this house and part lot to his son. James H. Jr. and Ada Matilda had two children, James H. III and Gilbert. This house is known in the deeds as the "Nannie Potter House," as she was never married and was the sister of James H. Jr. and W.V.B. Potter.

This house is a more modern one, having been built in 1910. It has a nearly full wraparound porch across the front and down the east side. The entryway is to the far west side of the front porch, with a second story. This home too has been sold and maintained thoughtfully by the new owners.

Tourism Today

The BHA Restoration Grounds and Buildings

Now that you have had a taste of some of the old houses and homes built by early settlers and families of this area, it is time to stop at the Beaufort Historic Association (BHA) restoration grounds in the first block of Turner Street, take a look at the site and visit the gift shop in the Safrit Center. On the grounds you will be able to see up close and personal the courthouse of 1796 as it has been restored to its original use, as well as the nearby jail of 1829. And you don't want to miss the apothecary and doctor's office. In addition to these three buildings referred to earlier in this book, there are other structures, such as the Leffers Cottage, the Josiah Bell House and the Rustull House Art Gallery. A house across the street, formerly known as the Joseph Bell House 1767 and recently determined to be a Manson house of 1825, is also a part of the restoration grounds.

Every year on the last full weekend of June, the BHA hosts the Old Homes and Gardens Tour, which features many of the houses identified in this volume as well as tours of the buildings on the grounds. Other events occur throughout the year to which members and prospective members are invited. The BHA also greets children from across the state during school tours with hands-on lessons about the way of life in the early days of Beaufort.

The Beaufort Historic Association was established in the mid-twentieth century with tours, a pirate invasion and antique shows. Not only has it become one of the premier places for tourists to visit, but it has also grown over the years into a showplace of early Beaufort architecture and construction. Costumed docents are here to meet, greet and teach you about these structures as well as answer questions you might have. It is a place you don't want to miss.

The North Carolina Maritime Museum and Facilities

The other place not to miss is the North Carolina Maritime Museum on Front Street, just around the corner from Turner Street. This museum began in 1951 as the Hampton

The North Carolina Maritime Museum. *Courtesy of the author.*

Mariner's Museum when workers at the U.S. Fish and Wildlife Service laboratory on Piver's Island needed a place to store their collection of marine specimens. Placed under the auspices of the North Carolina Museum of Natural History, a division of the Department of Agriculture, the state legislature officially named the collection for W. Roy Hampton, whose years with the Board of Conservation and Development as well as the Fish and Wildlife Service had been instrumental in keeping and organizing the collection.

In the twenty years prior to the legislative action, the collection had been "floating around" from agency to agency and town to town within the county. Through the desire of many local folks and groups who understood the value of such a resource, it eventually stayed in Beaufort. Another twenty years went by before a local citizen and artist, Charles R. McNeill, made a proposal to then–North Carolina Agriculture Commissioner James Graham for the formal location and opening of what became known as the Hampton Mariner's Museum. Located in a rental space on Turner Street next to the Beaufort Historic Association's restoration grounds, and with sparse staff, Mr. McNeill created a place for the collection and used his artistic skills to do more in the way of displays and written explanations about what visitors would see. Ten years after operating the museum in the rental space, land on Front Street was donated. The world-renowned North Carolina Maritime Museum was built and later property across the street on Taylor's Creek was acquired and became the Watercraft Center.

The North Carolina Maritime Museum, operated through the auspices of a division of the state government, is presently fulfilling a dream of building the Olde Beaufort

Junior sailors plying the waters of Town Creek. *Courtesy of the author.*

Seaport on Gallant's Point near Town Creek. In addition to holding sailing classes for young children, as well as sponsoring the Beaufort Oars, a rowing group, the items from the wreck of the *Queen Anne's Revenge* are on display in the first building erected on the site.

THE TALL SHIPS VISIT BEAUFORT

In June 2006, the Friends of the Maritime Museum along with Pepsi brought Americas' Sail to Beaufort and the Olde Seaport Village, as well as to the port in Morehead City. Americas' Sail was begun in 1986 to initiate a regularly scheduled international tall ship race in the Western Hemisphere. In 2002, the race was held in the Caribbean and the Gulf of Mexico. Class-A ships raced from Curacao to Montego Bay, with the *Cisne Branco* of Brazil winning the gold trophy. The Class-B racing trophy was won by none other than Beaufort's own pirate and privateer Sinbad on the *Meka II*. This year the sailing began in Brazil and ended in Beaufort.

The *Cisne Branco* came from Brazil and was docked at the North Carolina State Port in Morehead City along with the *Virginia*, a pilot schooner 122 feet long built in 2004 from Norfolk, Virginia. The Brazilian ship was built in 1999, a square-rigged clipper, 249 feet long out of Rio de Janeiro. This ship is the training vessel for members of the Brazilian navy and serves as a floating embassy, crossing the oceans that unite nations. Her name means "White Swan." A quote from the book that they give to newcomers on board says, "If life is really the art of encounters, the oceans are its colours, words and

One of the tall ships at the Olde Beaufort Seaport docks at Gallant's Point, part of the Pepsi Americas' Sail Tall Ship event, June 30–July 5, 2006. *Courtesy of the author.*

The *Meka II*, Captain Sinbad's winning ship, at the Olde Beaufort Seaport dock at Gallant's Point during the Pepsi Americas' Sail Tall Ship event. *Courtesy of the author.*

The Cedars Inn Bed & Breakfast, third block of Front Street. *Courtesy of the author.*

musical notes, always bringing people closer and bridging the most distant lands. Life begins at sea. It is from there that history moves forth. Its main chapters are connected to the sea."

The ships that came into Beaufort Harbor along Front Street included the *Ada Mae*, a skipjack built in 1915 out of New Bern, North Carolina; the *Compass Rose*, a gaff-rigged schooner built in 1970 out of Key West, Florida; the *Serenity*, a two-masted, gaff-rigged schooner built in 1986 out of Cape Charles, Virginia; and the *Three Belles*, an Angleman/Davies ketch built in 1966 out of Rockport, Maine.

At the Olde Beaufort Seaport village dock was *A.J. Meerwald*, a gaff-rigged schooner built in 1928 out of Bivalve, New Jersey; *Alliance*, a traditional three-masted, gaff-rigged schooner built in 1995 out of Yorktown, Virginia; *Jeanie B*, a two-masted, gaff-rigged schooner built in 1986 out of Greenville, North Carolina; *Leopard*, a two-masted, gaff-rigged schooner built in 1994 out of Chesapeake Bay, Virginia; *Margaret*, a cutter-rigged sloop or yawl built in 1904 out of Bristol, Rhode Island; *Phoenix*, a two-masted, gaff-rigged schooner built in 1984 out of Oyster Bay, New York; *Wolk*, a topsail schooner built in 1982–3 out of Key West, Florida; and the Beaufort-based *Meka II*, a brigantine built in 1967 by her captain, Sinbad.

The Pepsi Americas' Sail event began on June 30 and ended July 5. Thousands of people from all over the country came to Beaufort to watch the ships race, tour them and see the fireworks displays of the Fourth of July. It was quite an event, and one that will long be remembered by townsfolk and visitors alike.

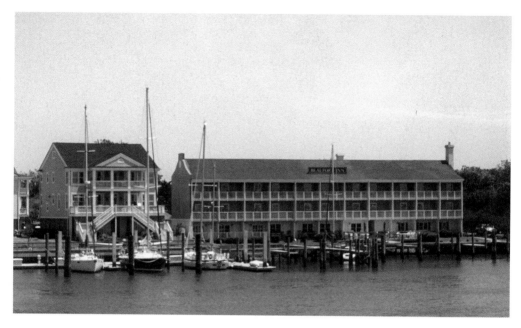

The Beaufort Inn as seen crossing Gallant's Channel into Beaufort. *Courtesy of the author.*

BEAUFORT: A PLACE TO VISIT, SLEEP AND EAT

We welcome visitors and hope that you enjoy your time here, strolling our streets, taking in the sights, looking at the houses and reading about the history of our small seaside village. We hope you remember Beaufort the way she was, and in some cases remains today, with the harbor full of pleasure boats, sailboats and even some of the larger deepwater fishing boats that dock during special tournaments. Town Creek also continues to be a place of refuge for many boaters who either live here or are visiting.

While you are visiting Beaufort, we hope that you are staying at one of the many inns or bed-and-breakfast places that have opened in recent years. Along Front Street in the third block there is the Cedars Inn, which is actually two early houses built in the 1700s, and the Elizabeth Inn next door, also an early home of a well-to-do businessman. In the sixth block of Front Street is the new Inlet Inn, not to be confused with the old Inlet Inn that has been razed for the bank building and parking lot at the corner of Pollock and Front Streets.

At the west end of Ann Street is the Beaufort Inn, built in 1987 overlooking Gallant's Channel. You can't miss this inn either coming across the drawbridge into Beaufort or riding down Ann to the inn, where the American and state flags fly constantly. Forty-four well-appointed rooms are available, as well as the hot tub spa, workout room and the grassy area where sun shines nearly every day—a great place to rest in a lounge chair, read a book or watch the boats and boaters go from the inlet or Taylor's Creek to and from Town Creek. Guests are greeted on Friday and Saturday afternoons with tea, coffee, homemade cookies, cheese and crackers. Docking facilities are available for those

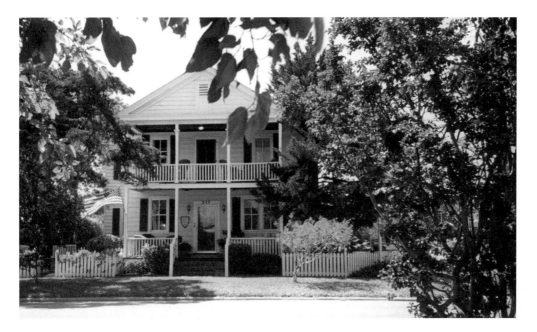

The Delamar Inn Bed and Breakfast, corner of Turner and Broad Streets. *Courtesy of the author.*

arriving in their own boat. Farther down Ann Street, the Potter house, home of William Jackson and his wife, Elizabeth Davis Potter, is now the Ann Street Inn, providing respite and peace from a busy week.

On the side or cross streets beginning with Turner Street's second block, there are the Captain's Quarters, the Anchorage House and the Delamar Inn, all three in older houses with owners who welcome you with open arms and wonderful rooms as well as a spot of tea in the afternoon and breakfast in the morning. Craven Street offers the Langdon House Bed & Breakfast, with the same fine courtesy and light meal as those on Turner Street. It is also in one of the older Beaufort homes. Queen Street is the home of the Pecan Tree Inn, with bedrooms large and airy, comfortably appointed and again, a welcome by the hosts and tea and toast in the morning.

If you are bringing a pet, you might wish to consider lodging at the Carteret County Home & Bed and Breakfast located on Highway 101 just north of town. Completely restored in the 1990s, the County Home, as it's known locally, was originally just that in the early 1900s. After closing to the poor and destitute, the building languished into disrepair until a young couple on a sailboat happened to town. They purchased the old run-down place and have turned it into a home away from home for travelers. Since they too have a dog and cat, they decided that some of their visitors might also like to bring pets. Thus this is one of the only places in Beaufort where you, your family and your pets can rest for the night or longer. The other is called the Red Dog Inn in the first block of Pollock Street.

No matter the style of home away from home you prefer, you can find it in Beaufort, along with the numerous restaurants. Front Street abounds with these, some on the

waterside and others located on the north side of the street. The side streets of Turner and Queen also have wonderful places to get your fill. Other options not in the immediate vicinity of downtown include pizza houses and burger and fries places.

Be sure to walk the boardwalk, catch sight of someone sailing one of the smaller boats, take a ride on one of the tour boats and get a good look at some of the large yachts docked as well as sailing ships anchored in Taylor's Creek. And when you are to the north of town, check out the vessels moored in Town Creek, a harbor of refuge.

Again, it all depends on your taste. Have fun, eat well, sleep well and enjoy the town while you are here.

BIBLIOGRAPHY

Barbour, Ruth P. "Carteret's 50 Years in Aviation." *Carteret County News-Times*, 1980.

Bookhout, Dr. C.G. "The First Quarter Century 1838–1963." *DUML News* 5, no. 2 (Fall 1987).

Branch, Paul. *Fort Macon, A History*. Mt. Pleasant, SC: Nautical and Aviation Publishing Company of America, Inc., 1999.

Carteret Historical Research Association. *The Heritage of Carteret County*, vols. 1 and 2, 1982.

Costlow, Dr. John D. "DUML Celebrates Half a Century." *DUML News* 6, no. 1 (Spring 1988).

Costlow, Dr. John, and Virginia Duncan. Conversation about the Duncan family history and the houses built by them, 2006.

Davis, Maurice. *History of the Hammock House and Related Trivia*. April 1984.

Dudley, Jack. "Beaufort, An Album of Memories." Self-published, 2004.

Haldeman, George Bowman, to his mother, 1885–86 while at the Johns Hopkins Laboratory, Gibbs House, Beaufort. Jane Addams Memorial Collection, University of Illinois.

Hubbard, Jackie. Chairman of the Apothecary Shop at the Beaufort Historical Association restoration grounds. "A History of the Apothecary," notes and comments about the building and Dr. George Davis.

National Geographic. "Menhaden—Uncle Sam's Top Commercial Fish." 1949.

National Park Service, U.S. Department of the Interior. *Cape Lookout National Seashore Newspaper*. Superintendent Bob Vogel and other contributors.

Paul, Charles L. "Colonial Beaufort." Report read at the regional meeting of the North Carolina Literary and Historical Association, April 1963.

Phillips, Tricia. Conversation with the author about history of the Potter family and their houses, 2006.

Records of St. John's Parish Vestry Minutes, 1742–1843. St. Paul's Episcopal Church, Beaufort.

Records of the Town of Beaufort, 1774–1877. Town Hall, Beaufort.

Sandbeck, Peter B. "Beaufort's African-American History and Architecture." Report prepared for the Beaufort Historic Preservation Commission, July 1995.

Simpson, Susan. "A History of the Library." Write-up by the librarian at the Carteret County Public Library. http://carteret.cpclib.org/cart/ccplhistory.htm.

Wheatly, Jule. Conversation with the author about the article by Art Lathan and the Beaufort menhaden plant as well as others in the area, 2006.

Wilson, Mamré Marsh. "Courthouse of 1796." Report to the membership of the Beaufort Historical Association regarding the restoration of the courthouse, September 1997.

————. "Prisons, Gaols, Jails of Beaufort and Carteret County." Unpublished history of the jails of Beaufort and Carteret County. 2004.

Wilson, Mamré Marsh, and Beaufort Historical Association. *Beaufort, North Carolina*. Charleston, SC: Arcadia Publishing, April 2002.

Wolfe, Dr. Douglas A. *A History of the Federal Biological Laboratory at Beaufort, N.C. 1899–1999*. Department of Commerce, NOAA, 2000.

Wrenn, Tony. Survey of the town of Beaufort used in the application for the Beaufort Historic District to be included in the National Register of Historic Places, 1974.

Please visit us at
www.historypress.net